D0629869

THE ART OF
Motherhood

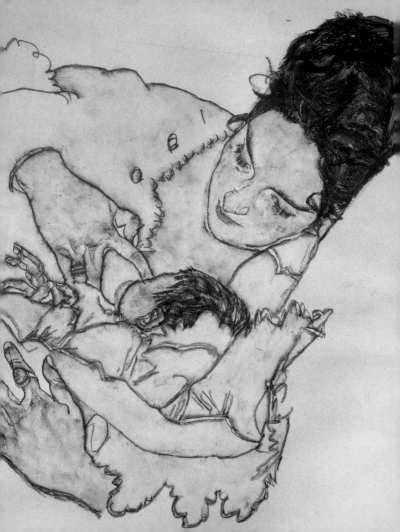

Marta Alvarez González

THE ART OF
Motherhood

Translated by Anthony Shugaar

The J. Paul Getty Museum
Los Angeles

Italian edition © 2009 Mondadori
Electa S.p.A., Milan
All rights reserved.

English translation
© 2010 J. Paul Getty Trust

First published in the United States
of America in 2010 by
The J. Paul Getty Museum,
Los Angeles

Getty Publications
1200 Getty Center Drive, Suite 500
Los Angeles, California 90049-1682
www.getty.edu/publications

Printed in Hong Kong

Library of Congress Control Number:
2009938660

ISBN 978-1-60606-015-5

Front Cover: Élisabeth-Louise
Vigée-Lebrun, *Madame Vigée-Lebrun and Her Daughter
Jeanne Lucie Louise*, detail,
1789, Musée du Louvre, Paris.

Back Cover: George Dunlop
Leslie, *Alice in Wonderland,*
detail, 1879. Libraries and
Museums, Brighton, England.

Spine: Raphael, *Madonna
della seggiola,* 1513–14,
Palatine Gallery, Pitti Palace,
Florence.

On page 2: Egon Schiele,
Nursing Mother, detail, 1917,
private collection.

Right: Gustav Klimt, *The
Three Ages of Woman*, detail,
1905, Galleria d'Arte
Moderna, Rome.

On page 6: Paolo Veronese,
*Portrait of Countess Livia da
Porto Thiene and Her
Daughter Porzia*, detail, 1556,
The Walters Art Museum,
Baltimore.

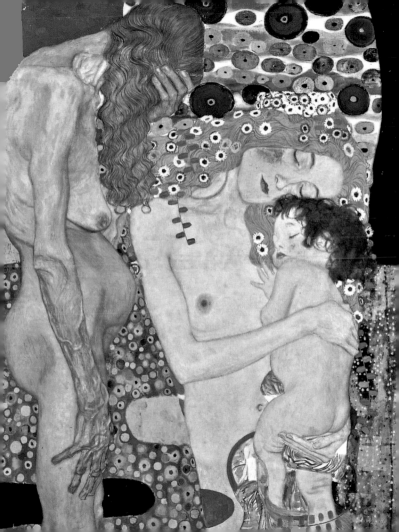

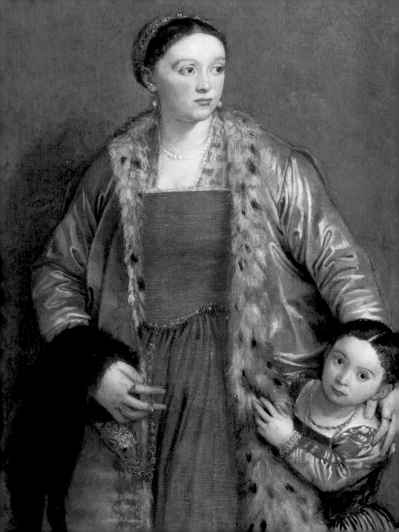

The Love of Our Lives

Mom, momma, mamma, maman, mama, mum, Mutti . . . whatever the language, the word "mother" is inevitably transformed into a different term, easier to pronounce and, most important, more affectionate, when it is used within the family circle. As children, we learned to call out for our mother by repeating the first syllables we were capable of forming. The resulting sounds—mama—developed in a spontaneous and entirely natural way to fulfill an infant's need to communicate with the one person who would long remain the primary focus of attention and contact, the source of food and daily care.

Later, as we grew up, we continued using the same simple sequence of labial sounds—a technical description of the letter "m"—especially in private, perhaps because, aside from the influence of habit and despite the passage of years and the acquisition of maturity and experience, our mother remains for each of us exactly what she was when we were children: the beginning of everything, the point of departure for each of our lives. In the collective imagination, the mother is seen not only as the wellspring of life but also as synonymous with a diverse array of values, from mercy and forgiveness and self-sacrifice to altruism and understanding and unquestioning

support; from renunciation of one's own wishes to a total commitment of oneself. In contrast with many other emotions that are perhaps equally intense but far more ephemeral, mother love constitutes one of the few fixed points of reference upon which we can count in our lives, a source of comfort and reassurance in times of trouble, an anchor to which we cling throughout our lives.

In brief, we expect just about everything from our mothers, even when life forces us to admit our mothers' weaknesses and shortcomings. And that is because, at least in our collective imagination, a mother remains an extraordinary figure, in some cases more divine than human, and certainly an image of virtue and wisdom.

The images presented in this volume show us that ever since earliest times, humanity has felt a need to shape and express—with pen as well as with paintbrush and chisel—the great power and complexity of the maternal relationship.

From the very beginning, the supernatural aspects of motherhood linked to its reproductive power emerge clearly. To cite just one example, let us think of the so-called Venuses created in the early Paleolithic era and the florid abundance of their rotund forms, a clear reference to the progressive transformation of the body of a woman about to become a mother. It is surely no accident that one of the first creations in the history of art was an image that unmistakably describes and invokes fecundity, the generation of life itself.

Many centuries later in Western culture, the idea of abundance and prosperity was still frequently portrayed in the guise of a young woman feeding and caring for her children,

in keeping with an iconographic scheme that was common in classical antiquity and that emerged as well in Christianity. And what should we say about the enduring fascination of the Virgin Mary, Mother of God, but also an all-too-human mother, often depicted by artists in precisely those moments of everyday life described in the Gospels or handed down by tradition, moments that made her a model for any ordinary mother. Among those moments, we might mention Mary protecting her son from impending danger by taking him to safety in Egypt, suckling him as an infant, warming him against the cold, sewing clothing for him . . .

Ranging from ancient Egypt and classical Greece and Rome to the most avant-garde work of modernity, from pre-Columbian cultures to contemporary artists, the images reproduced in these pages cover a vast geographical territory and arc of historical time. The same is true of the texts that accompany the images, consisting of fragments of works of literature, lullabies, pop songs, and famous phrases from a broad range of times and sources.

And yet the gestures, expressions, and sentiments that emerge from these artistic images and literary descriptions remain the same: the immense sweeping happiness that follows the agony of birth, the warmth of an embrace, the intimacy of nursing, the details of daily care and attention, the admonishment of a misbehaving child, and the infinite affection contained in a kiss, images, when all is said and done, that each of us still carry with us, deep in our hearts and deep in our memories.

A mother's love is the beginning
and end of every love.

Georg Walter Groddeck

Maternity Idol, from Tell Brak (Syria), 3500–3000 B.C.,
Archaeological Museum Aleppo.

*H*er feet are set in darkness—at Her feet
 We kneel, for She is Mother of us all—
A mighty Mother, with all love replete.

Anonymous

Woman with Two Sons on Her Shoulders, detail, from
the Tomb of Horemheb (Egypt), fourteenth century B.C.,
Rijksmuseum van Oudheden, Leiden.

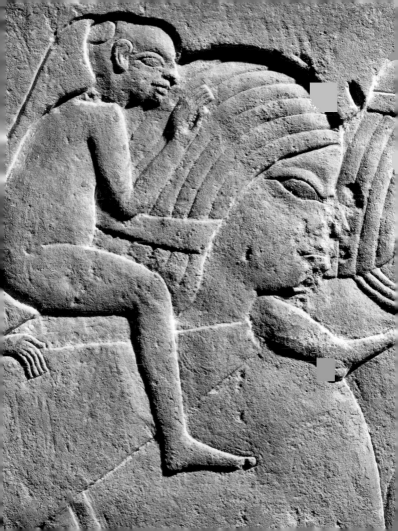

A good mother sees more with one eye
than a father does with ten.

Italian proverb

Mother and Child, from Tlatilco (Mexico), 1400–600 B.C.,
National Museum of Anthropology, Mexico City.

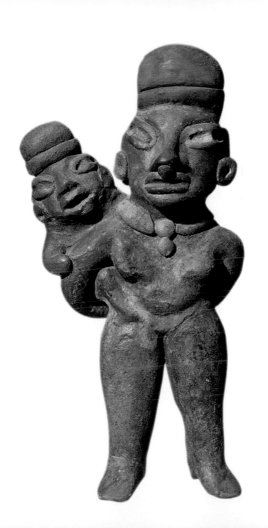

It is at our mother's knee that we acquire our noblest and truest and highest ideals, but there is seldom any money in them.

Mark Twain

Stela of Tarhunpiyas (Mother with Child Standing on Her Lap), from Marash (Armenia), eighth century B.C., Musée du Louvre, Paris.

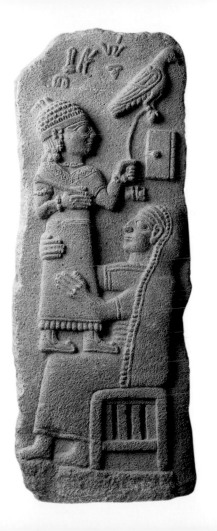

*M*others *are more powerful than gods.*

Chinese proverb

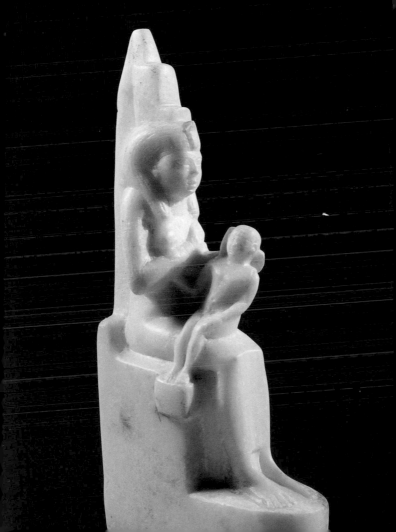

[Themistocles told his son] that he had the most power of anyone in Greece: "For the Athenians command the rest of Greece, I command the Athenians, your mother commands me, and you command your mother."

Plutarch

Pitsa panel—a painted wooden tablet with a scene of a sacrifice, found near Pitsa, Corinthia (Greece), 540–530 B.C., National Archaeological Museum, Athens.

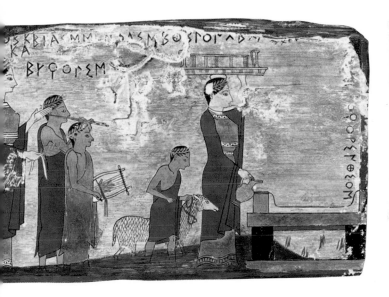

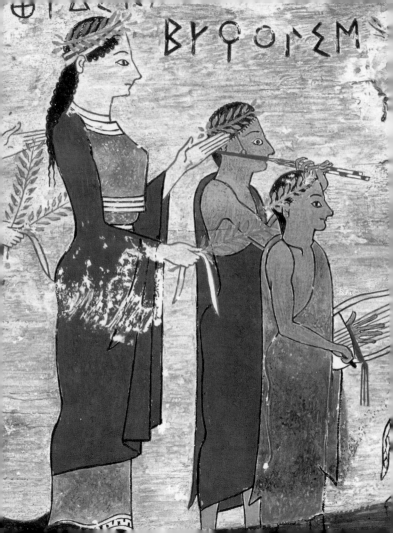

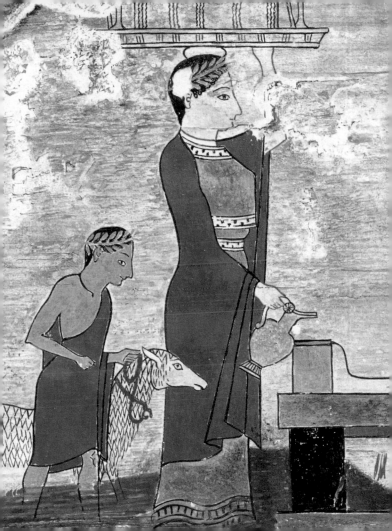

A mother's arms are made of tenderness and children sleep soundly in them.

Victor Hugo

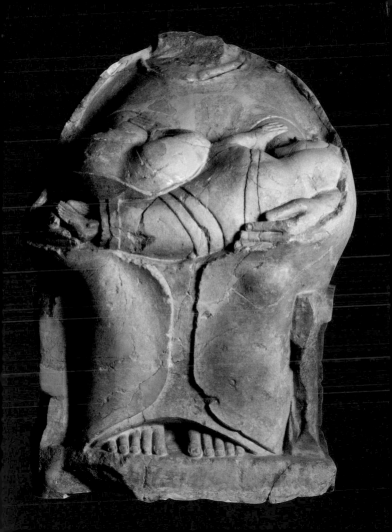

*T*o the eyes of a mother, all children
are beautiful.

Italian proverb

Mother and Son, sixth century B.C.,
Museo Archeologico, Cagliari, Italy.

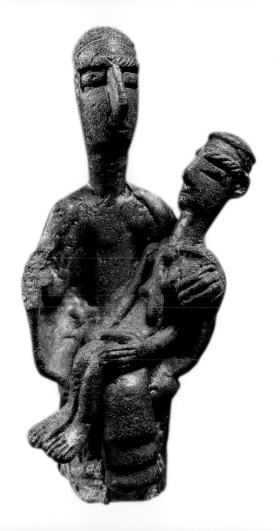

*C*hildren are the anchors that hold a mother to life.

Sophocles

Young Woman with Her Son, ca. 410 B.C.,
Kerameikos Archaeological Museum, Athens.

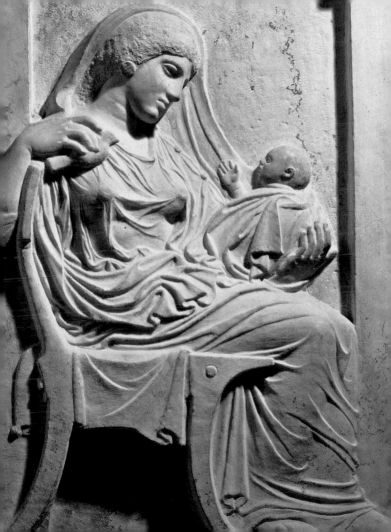

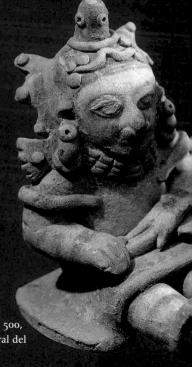

*W*omen are never tired of being mothers,
and . . . *they would rock death itself, if
death came to sleep on their knees.*

Maurice Maeterlinck

Women with Children, from
Manabi (Ecuador), 500 B.C.–A.D. 500,
Museo Nacional del Banco Central del
Ecuador, Quito.

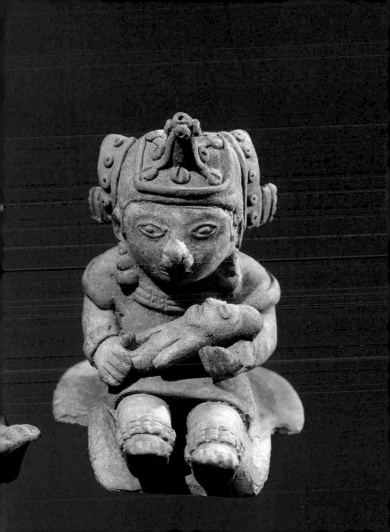

Oh, how powerful is motherhood. It possesses an enchantment that bewitches all women, making them fight fiercely to defend their child.

Euripides

Woman with Child, from Chandraketugarh (India), second century B.C., Musée Guimet, Paris.

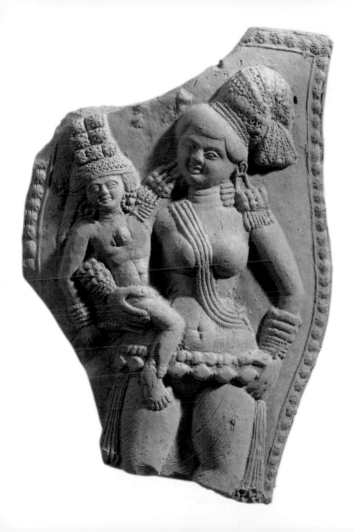

What do girls do who haven't any mothers to help them through their troubles?

Louisa May Alcott

Woman with Child, late second century B.C.,
Musée du Louvre, Paris.

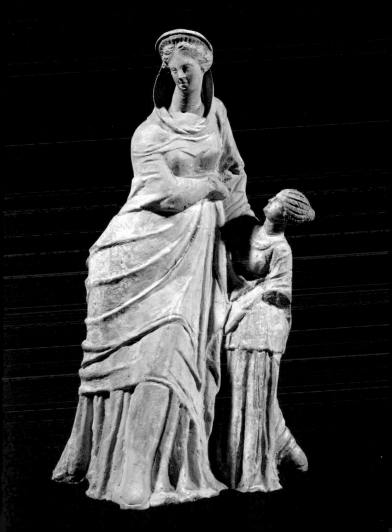

*W*hat good mothers and fathers instinctively feel like doing for their babies is usually best after all.

Benjamin Spock

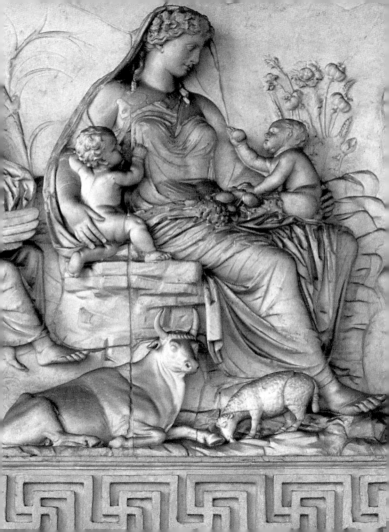

There is none,
In all this cold and hollow world, no fount
Of deep, strong, deathless love, save
 that within
A mother's heart.

Felicia D. Hemans

Danaë, Perseus, and the Fishermen, detail, A.D. 1–50,
National Archaeological Museum, Naples.

A mother's love triumphs over all difficulties, and perceives no impossibilities.

Cornelia Paddock

Woman Offering a Child, 3300 B.C.–A.D. 1000, Museo Nacional del Banco Central del Ecuador, Quito.

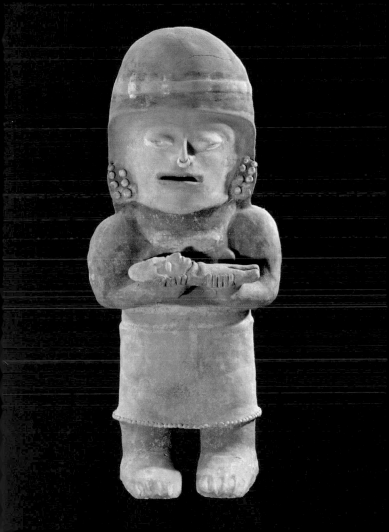

*W*hat youthful mother . . .
Would think her son, did she but see
 that shape
With sixty or more winters on its head,
A compensation for the pang of his birth,
Or the uncertainty of his setting forth?

William Butler Yeats

The Birth of Alexander, detail, from Baalbek,
Lebanon, fourth century A.D., National Museum
of Beirut, Beirut, Lebanon.

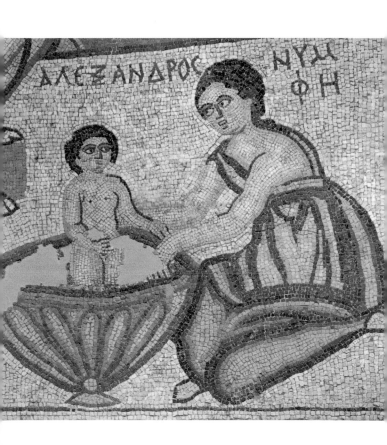

We are the Ancient People;
Our father is the Sun;
Our mother, the Earth, where the mountains tower
And the rivers seaward run.

Edna Dean Proctor

Mother and Son, from Jaina, Mexico, A.D. 600–900,
Museo de Sitio y Zona Arqueológica de Palenque,
Palenque, Mexico.

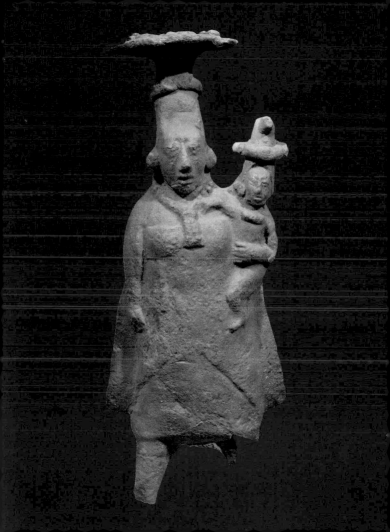

*A*s long as you have a mother,
you are safe; when you lose your
mother, you are defenseless.

Chinese proverb

St. Nicholas Refusing His Mother's Milk, detail,
1060–1066, Abbey of Novalesa, Chapel of Sant'Eldrado
(St. Eldrad), Novalesa (near Turin), Italy.

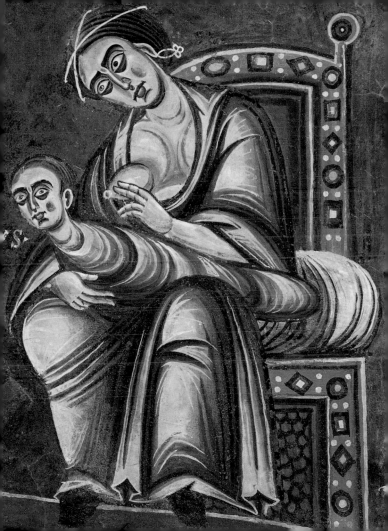

Who ran to help me when I fell,
And would some pretty story tell,
Or kiss the place to make it well?
My mother.

Jane Taylor

Mothers Caring for Their Children, ca. 1150,
St. Martin Church, Zillis, Switzerland.

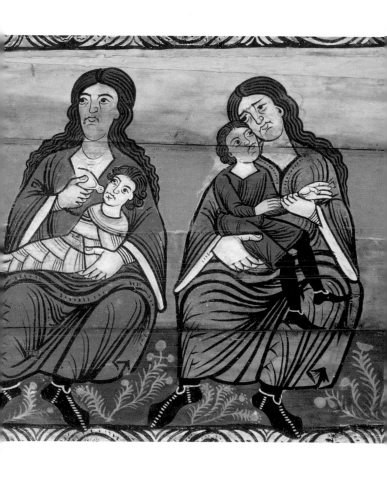

It is the nightly custom of every good mother after her children are asleep to rummage in their minds and put things straight for next morning, repacking into their proper places the many articles that have wandered during the day.

James M. Barrie

The Virgin Mary Turns on Her Bed to Touch Baby Jesus, late twelfth century, Cathédrale Nôtre-Dame de Chartres, France.

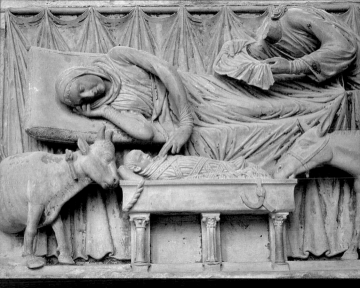

*T*he mother—*let us kneel!*—*the mysterious source of human life, in whom nature once again receives the breath of God, creator of the immortal soul.*

Pope Paul VI

Woman with Son, miniature from a thirteenth-century English manuscript, Biblioteca Nazionale Marciana (National Library of St. Mark's), Venice.

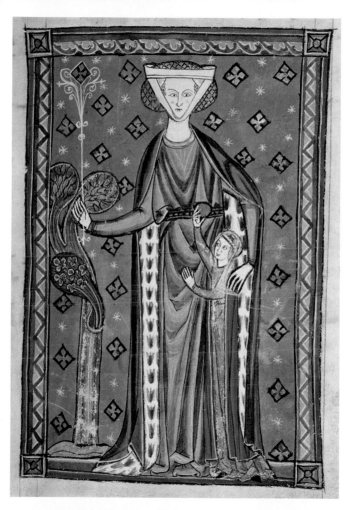

Poor Adam fell because he had no mother; he was never a child.

Miguel de Unamuno

Adam Preparing Food for Eve and Their Son,
mid-thirteenth century, Sainte-Chapelle, Paris.

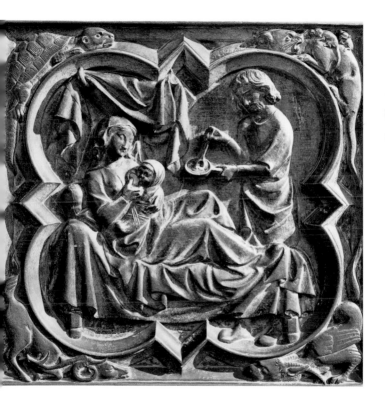

We can't form our children on our own concepts; we must take them and love them as God gives them to us.

Johann Wolfgang von Goethe

Giotto, *Birth of Jesus*, 1303–1305, Scrovegni Chapel, Padua.

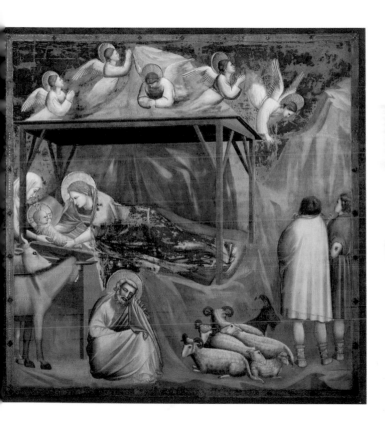

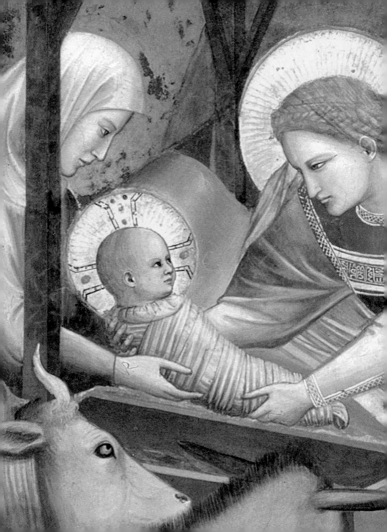

A child will never know all the
troubles he has caused his mother.

Chinese proverb

Simone Martini, *Miracle of the Child Falling from the Balcony*,
1324, Pinacoteca Nazionale (National Gallery), Siena.

The heart of a mother is a deep abyss at the bottom of which you will always find forgiveness.

Honoré de Balzac

Simone Martini, *Christ Discovered in the Temple*, 1342, Walker Art Gallery, Liverpool.

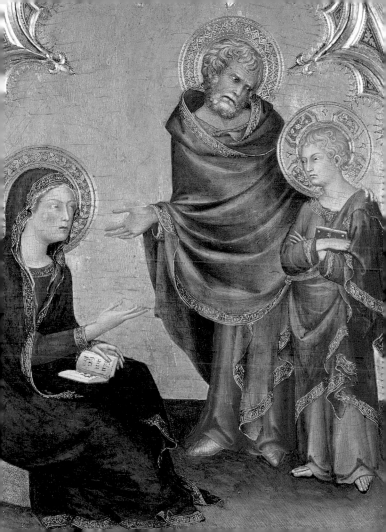

*A*nd Adam called his wife's name Eve; because she was the mother of all living.

Genesis 3:20

Pietro Lorenzetti, *Nativity of the Virgin*, 1342, Museo dell'Opera del Duomo, Siena.

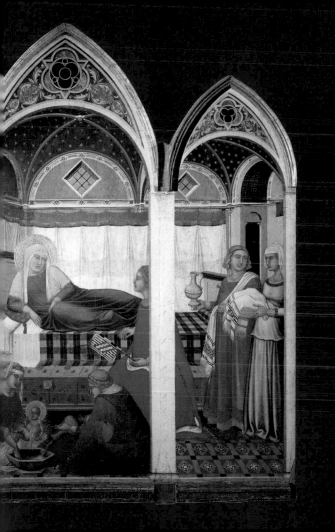

*S*ome are kissing mothers and some are scolding mothers, but it is love just the same, and most mothers kiss and scold together.

Pearl S. Buck

Niccolò di Pietro Gerini, *Delivery of Orphans to Adoptive Parents*, detail, 1386, Museo del Bigallo, Florence.

*E*very man, for the sake of the great blessed Mother in Heaven, and for the love of his own little mother on earth, should handle all womankind gently, and hold them in all Honour.

Alfred, Lord Tennyson

Theophanes the Greek, *Our Lady of the Don*, late fourteenth century, State Tretyakov Gallery, Moscow.

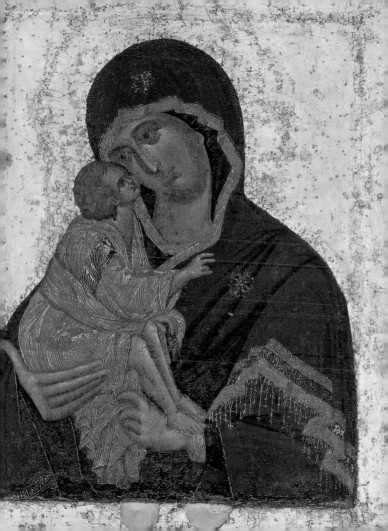

A *linen shirt stitched by a mother is* *warmer than a woolen mantle woven* *by a stranger.*

Finnish proverb

Bertram von Minden, *The Buxtehude Altar*, detail of the right panel, 1400–1410, Hamburger Kunsthalle, Hamburg, Germany.

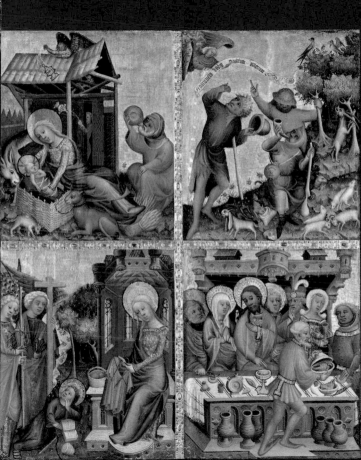

All night your moth-breath
Flickers among the flat pink roses.
I wake to listen:
A far sea moves in my ear.

Sylvia Plath

Conrad von Soest, *Nativity*, 1403–1404, Stadtkirche
St. Nikolaus, Bad Wildungen, Germany.

To maintain a joyful family requires much from both the parents and the children. Each member of the family has to become, in a special way, the servant of the others.

Pope John Paul II

Hector Mounts His Horse, Bidding Farewell to His Wife and Son, detail, 1410–1411, British Library, London.

76

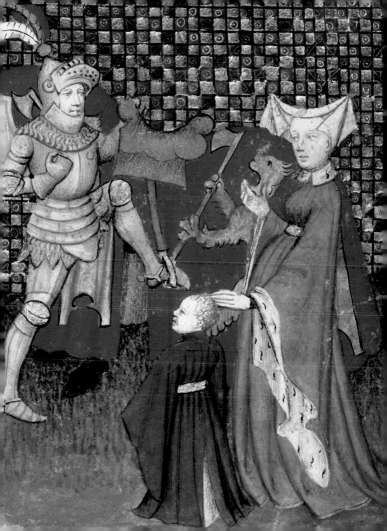

*U*nto the woman he said, I will greatly multiply thy sorrow and thy conception; in sorrow thou shalt bring forth children.

Genesis 3:16

Jan van Eyck, *The Birth of John the Baptist*, miniature from the Très Belles Heures de Notre-Dame, ca. 1422, Museo Civico d'Arte Antica, Turin, Italy.

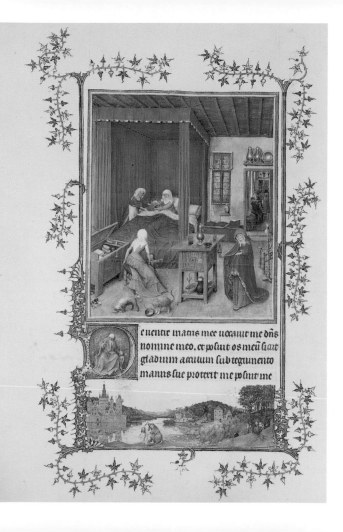

e uentre matris mee uocauit me dns
nomine meo, et posuit os meü siait
gladium acutum sub tegumento
manus sue protexit me posuit me

Let her have laughter with her little one;
Teach her the endless, tuneless songs to sing,
Grant her her right to whisper to her son
The foolish names one dare not call a king.

Keep from her dreams.

Dorothy Parker

Virgin Mary with Christ Child, detail, ca. 1420,
National Museum in Cracow, Poland.

A mother is proud of the son who has risen to the top, but she would give her life for the other son: the unfortunate son.

Libero Bovio

Birth of Alexander the Great, detail of a miniature from the codex Des Faits du Grand Alexandre, fifteenth century, Musée Condé, Chantilly, France.

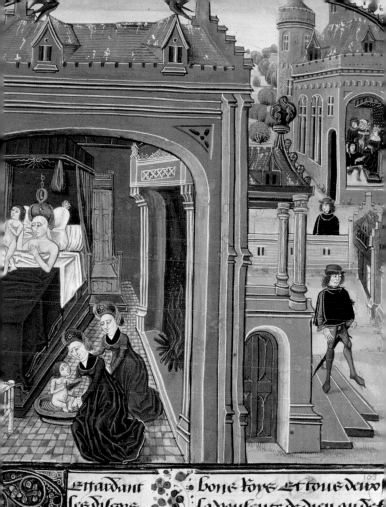

Estardant bone foye et tous deuoi

les discores la voulente de dien ou des

et infelicite tine le trup̄ que sa dur

Only mothers can think of the future— because they give birth to it in their children.

Maxim Gorky

French school, *Nativity of the Virgin Mary,* miniature from the *Vita Christi* of Ludolphus the Carthusian, fifteenth century, University of Glasgow Library, Glasgow.

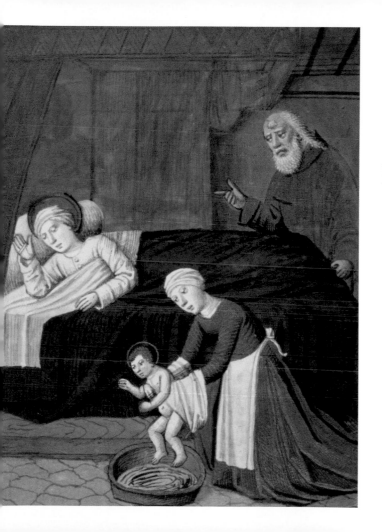

*Let France have good mothers,
and she will have good sons.*

Napoleon Bonaparte

French school, *Birth of Julius Caesar*, detail of a
fifteenth-century miniature, Musée Condé,
Chantilly, France.

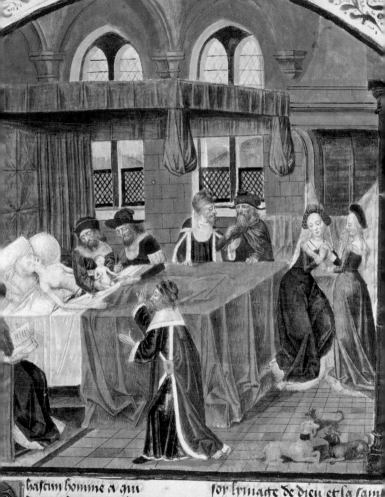

chastun homme a qui
dieu a donne raison
et entendement se

soy lymaige de dieu et la sam
ce parellement. et le corps ep
plus comun a beste et fuble et

The real religion of the world comes from women much more than from men —from mothers most of all, who carry the key of our souls in their bosoms.

Oliver Wendell Holmes

Attributed to Matteo di Giovanni, *Birth of the Virgin*, detail, 1450–1460, Musée du Louvre, Paris.

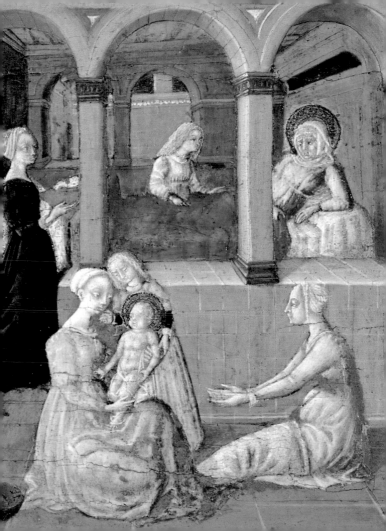

Mother most pure,
Mother most chaste,
Mother inviolate,
Mother undefiled,
Mother most amiable,
Mother most admirable,
Mother of good counsel,
Mother of our Creator,
Mother of our Savior.

Litany of the Blessed Virgin Mary
(Litany of Loreto)

Jean Fouquet, *Virgin and Child Surrounded by Angels*, detail
of the right panel of the Melun Diptych, ca. 1450, Royal
Museum of Fine Arts, Antwerp, Belgium.

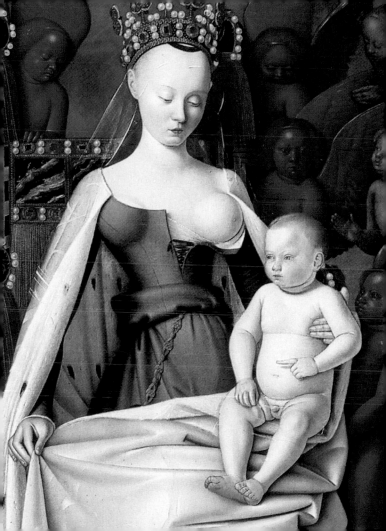

It has always seemed to me that every conception is immaculate and that this dogma, concerning the Mother of God, expresses the idea of all motherhood.

Boris Leonidovich Pasternak

Master of the Observance, *Nativity of the Virgin*, ca. 1450, Museo Civico, Asciano (near Siena), Italy.

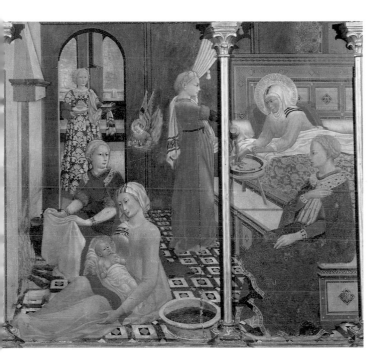

*The child begins in us
long before his beginning.
There are pregnancies
that last through years of hope,
decades of despair.*

Marina Tsvetaeva

Piero della Francesca, *Madonna del Parto*, ca. 1455–1460,
cemetery chapel, Monterchi (near Arezzo), Italy.

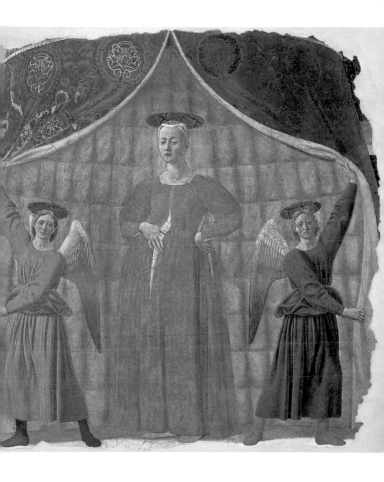

Your conscience is what your mother told you before you were six years old.

Brock Chisholm

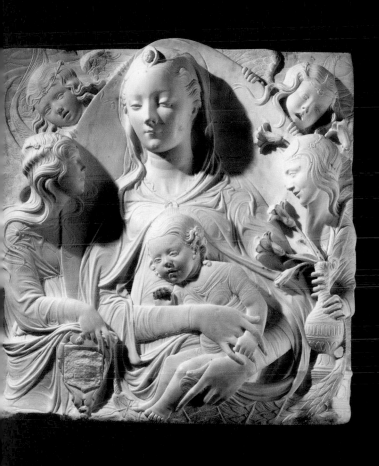

Two ounces of mother are as good as many fathers.

Piedmontese proverb

Geertgen tot Sint Jans, *The Holy Kinship*, 1490, Rijksmuseum, Amsterdam, the Netherlands.

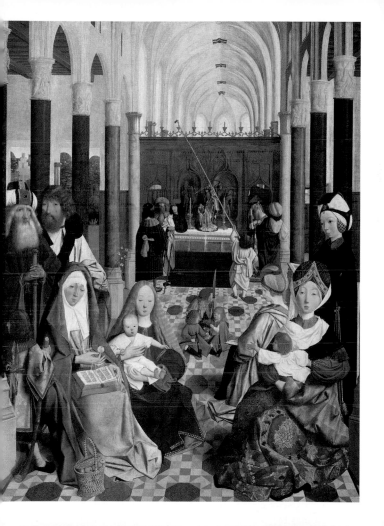

*T*he man who speaks badly of his mother is speaking badly of all women.

Carlo Dossi

Jean Bourdichon, *The Four Conditions of Society: Nobility*, 1490–1500, École des Beaux-Arts, Paris.

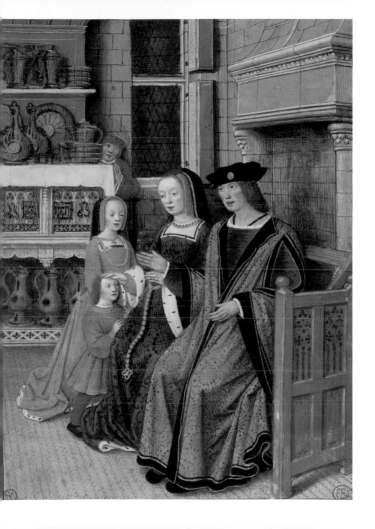

A father may turn his back on his child, brothers and sisters may become inveterate enemies, husbands may desert their wives, wives their husbands. But a mother's love endures through all.

Washington Irving

Michelangelo Buonarroti, *Madonna of the Stairs*, detail, ca. 1492, Casa Buonarroti, Florence.

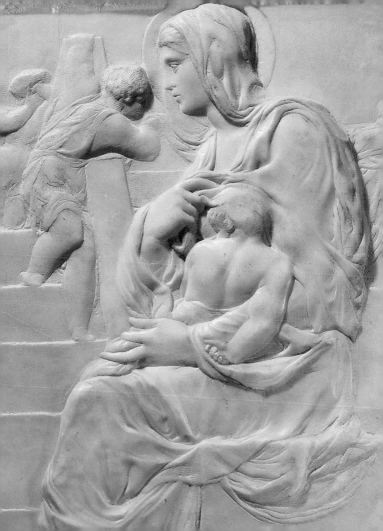

Boil, boil, little pot,
make a mush for my tot,
momma stirs
while baby sleeps;
sleep, sleep, my little darling,
or the mush will run away.

Lina Schwarz

Gerard David, *Madonna and Child with the Milk Soup,*
Royal Museum of Fine Arts, Brussels, Belgium.

So you want children, Madame Margherita? Sure, for the treasures they bestow on you. First, you carry them in your body for nearly a year, then you give birth at the risk of your life, you nurse them, you clean up after them, every time they hurt themselves you almost faint dead away, and when they grow up, that's the end of it: they take their hats and they leave you.

Giuseppe Gioacchino Belli

Hieronymus Bosch, *Hay Wagon Triptych*, detail, 1500–1502, Museo Nacional del Prado, Madrid.

You don't have to deserve your mother's love. You have to deserve your father's.

Robert Frost

Giorgione, *The Tempest*, 1505–1506,
Accademia, Venice.

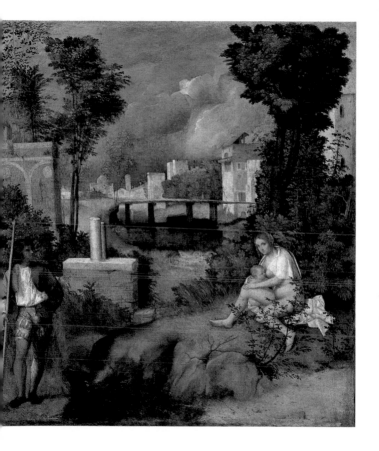

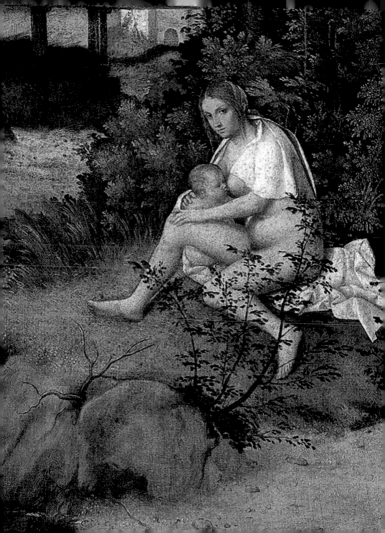

The joys of parents are secret; and so are their griefs and fears. They cannot utter the one; nor they will not utter the other.

Francis Bacon

Lucas Cranach the Elder, *Triptych with the Holy Kinship,* side panels, 1509, Städel Museum, Frankfurt, Germany.

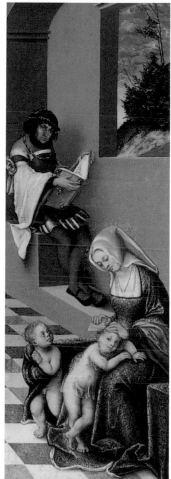

Thou Virgin Mother, daughter of thy Son,
Humble and high beyond all other creature,
The limit fixed of the eternal counsel,
Thou art the one who such nobility
To human nature gave, that its Creator
Did not disdain to make himself its
creature.

Dante Alighieri

Gerard David, *Rest on the Flight into Egypt*,
ca. 1510, Museo Nacional del Prado, Madrid.

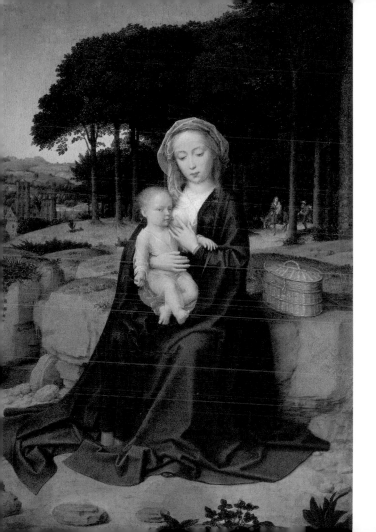

You can fool some of the people some of the time, but you can't fool mom!

George "Spanky" McFarland

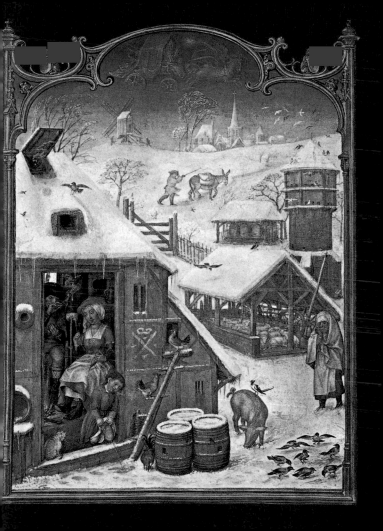

*Y*outh fades, love droops, the leaves of friendship fall; a mother's secret hope outlives them all.

Oliver Wendell Holmes

*What are Raphael's Madonnas
but the shadow of a mother's love,
fixed in permanent outline
forever?*

Thomas Wentworth Higginson

Raphael, *Madonna della seggiola (Virgin Mary with the Christ Child and Young St. John)*, 1513–1514, Palatine Gallery, Pitti Palace, Florence.

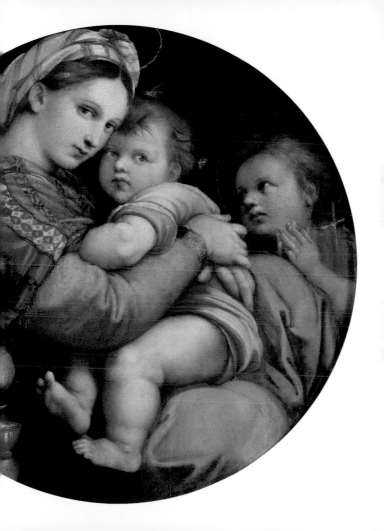

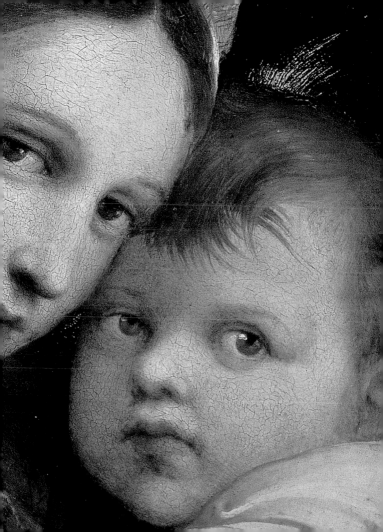

W*here parents do too much for their*
children, the children will not do much
for themselves.

Elbert Hubbard

Andrea del Sarto, *Charity*, 1518,
Musée du Louvre, Paris.

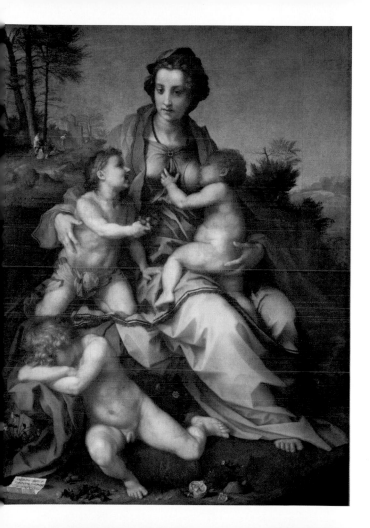

But, young mother, what do you hold in your arms? A machine of exquisite symmetry; the blue veins revealing the mysterious life-tide through an almost transparent surface.

Lydia Howard Sigourney

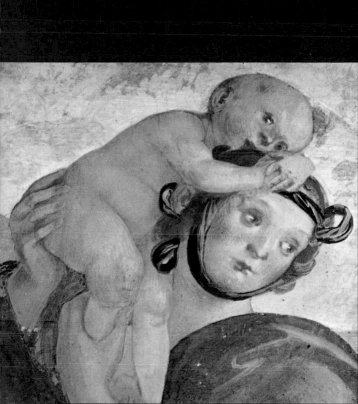

Blessed the baby who lives under the protection of a holy angel! O mama, I am that baby, and the angel, mama, is you!

Giovanni Bertacchi

Gaudenzio Ferrari, *Mother and Child*, detail from the Chapel of the Crucifixion, 1520–1524, Sacro Monte of Varallo (near Vercelli), Italy.

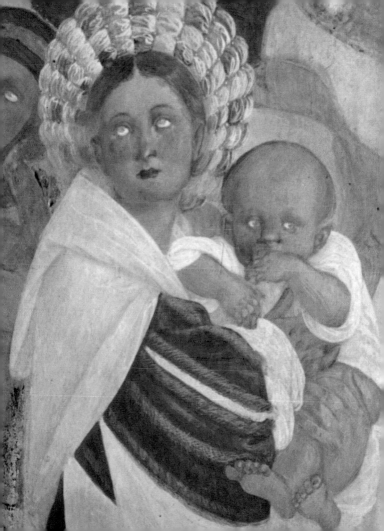

There is only one pretty child in the world, and every mother has it.

Chinese proverb

Lorenzo Lotto, *Nativity of the Virgin*, detail, 1525, San Michele al Pozzo Bianco, Bergamo, Italy.

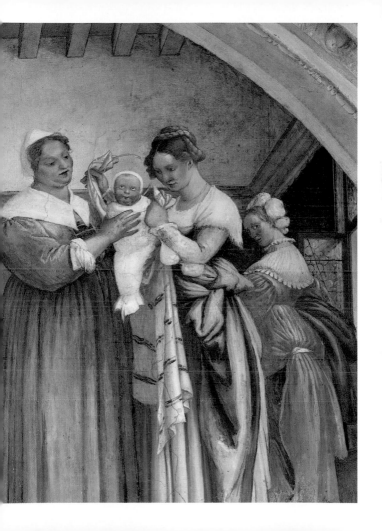

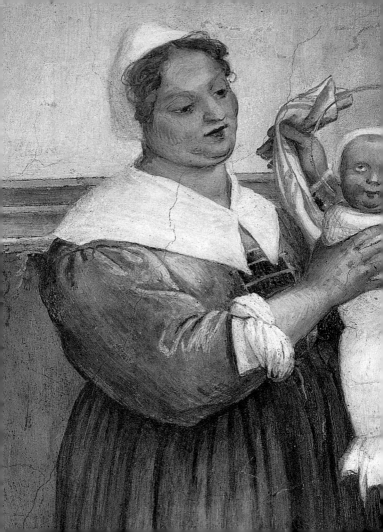

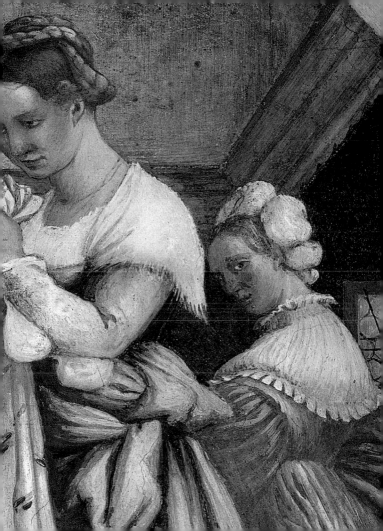

I dreamed I was under the roof of a manger, and I looked down and I saw an ox and an ass; and I saw a red cock perching on the hay-rack; and a woman hugging a child; and three old men in chain armour kneeling with their heads bowed very low in front of the woman and the child.

William Butler Yeats

German school, *Adoration of the Magi*, ca. 1530,
Victoria and Albert Museum, London.

*T*here never was a
child so lovely but his
mother was glad to get
him asleep.

Ralph Waldo Emerson

Lorenzo Lotto, *The Holy Family
with St. Catherine of Alexandria*,
1533, Accademia Carrara,
Bergamo, Italy.

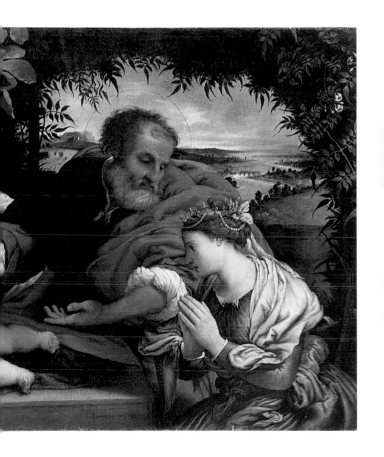

Hundreds of dewdrops to greet the dawn,
Hundreds of bees in the purple clover,
Hundreds of butterflies on the lawn,
But only one mother the wide world over.

George Cooper

Miniature from the *Stories of Medshnun and Leila*,
by Nur ad-Din Abd ar-Rahman Jami, ca. 1540,
Ehemals Gulistan Library, Teheran, Iran.

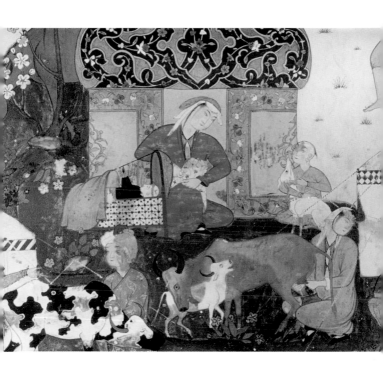

A woman's love
Is mighty,
but a mother's heart is weak,
And by its weakness overcomes.

James Russell Lowell

Agnolo Bronzino, *Eleanor of Toledo*,
ca. 1544, Uffizi Gallery, Florence.

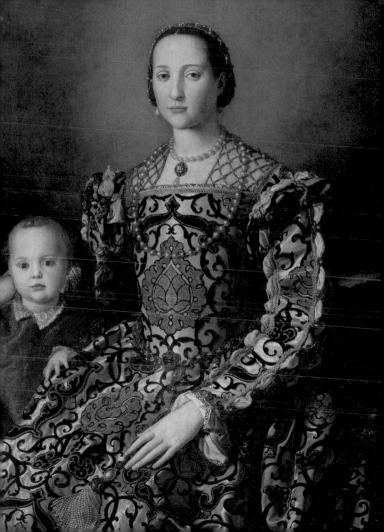

If we could find the first seed of all the good feelings and all the noble and great-hearted deeds of which we are so proud, that seed would almost invariably be found in the heart of our mother.

Edmondo De Amicis

Jacopo Tintoretto, *Presentation of the Virgin in the Temple*, detail, 1552–1553, church of the Madonna dell'Orto, Venice.

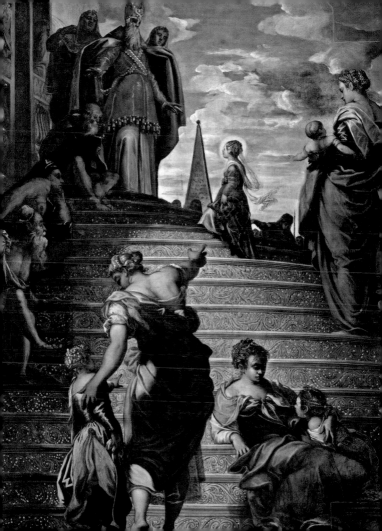

*A*s is the mother, so is her daughter.

Ezekiel 16:44

Paolo Veronese, *Portrait of Countess Livia da Porto Thiene and Her Daughter Porzia*, 1556, The Walters Art Museum, Baltimore.

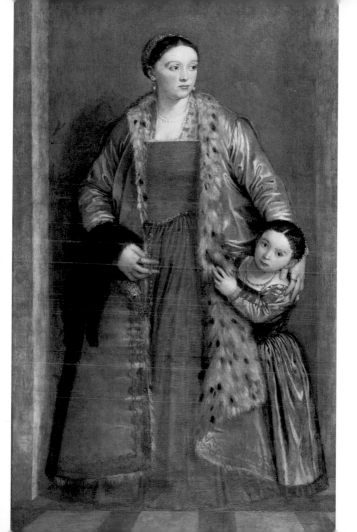

The precursor of the mirror is
the mother's face.

D. W. Winnicott

Luis de Morales, *Madonna and Child*, detail, 1568,
Museo Nacional del Prado, Madrid.

*N*ature's loving proxy,
the watchful mother.

Edward Bulwer-Lytton

*S*o when the great word "Mother!"
 rang once more,
I saw at last its meaning and its place;
Not the blind passion of the brooding past,
 But Mother—the World's Mother—
 come at last,
To love as she had never loved before—
To feed and guard and teach the human
 race.

Charlotte Perkins Gilman

Michelangelo Merisi da Caravaggio, *Rest on the Flight into
Egypt*, detail, 1590–1600, Doria Pamphilj Gallery, Rome.

*God could not be everywhere,
so he created mothers.*

Jewish proverb

Michelangelo Merisi da Caravaggio, *The Madonna
and Child with St. Anne (Madonna dei Palafrenieri)*,
1605, Borghese Gallery, Rome.

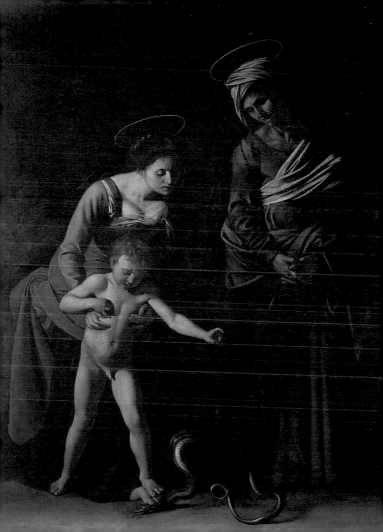

*W*hen asked if she was proud of her son she said: "Which one?"

Ida Stover Eisenhower, mother of Dwight David Eisenhower

Gottfried von Wedig, *Woman at the Virginal with Her Children*, 1615–1616, Wallraf-Richartz-Museum, Cologne, Germany.

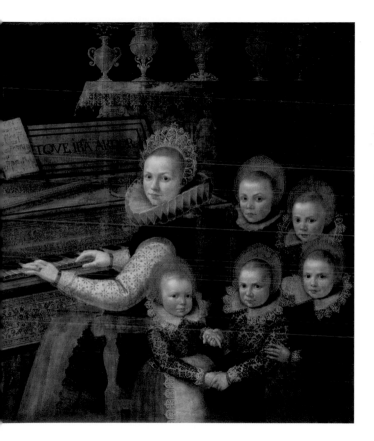

My prayer is that a baby Torquatus, on his mother's lap, may stretch out tiny hands to his father, and smile sweetly upon him with little lips half-parted.

Gaius Valerius Catullus

Jacob Jordaens, *The Virgin and Child with Saint John and His Parents*, 1620, National Gallery, London.

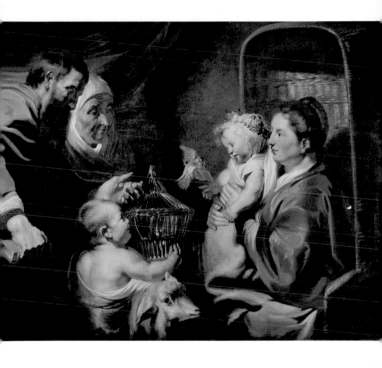

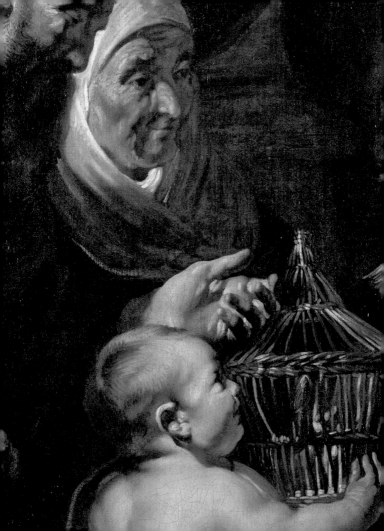

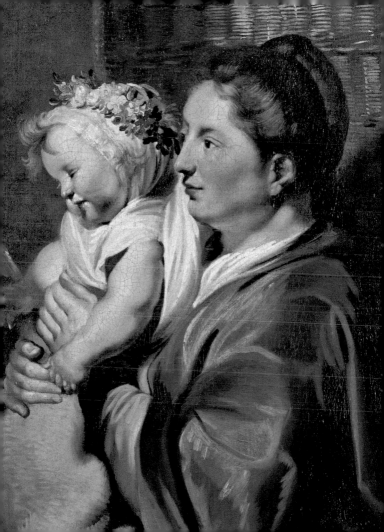

*M*other is the name for God in the lips
and hearts of little children.

William Makepeace Thackeray

Bernardo Strozzi, *Virgin Mary with Christ Child and Young St. John*, 1620, Gallery of Palazzo Rosso, Genoa.

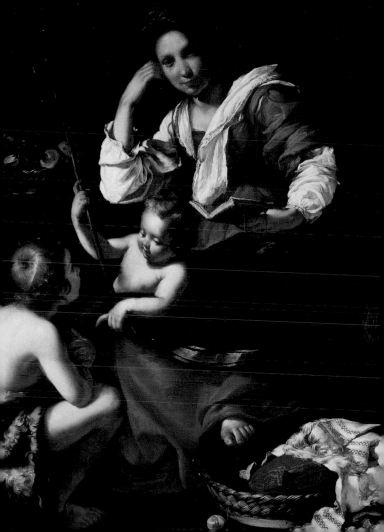

*M*y mother—my own mother, who
 died early,
Was but the mother of myself; but you
Are mother to the one I loved so dearly,
And thus are dearer than the mother
 I knew.

Edgar Allan Poe

Anthony van Dyck, *Family Portrait*, 1621,
The Hermitage, St. Petersburg, Russia.

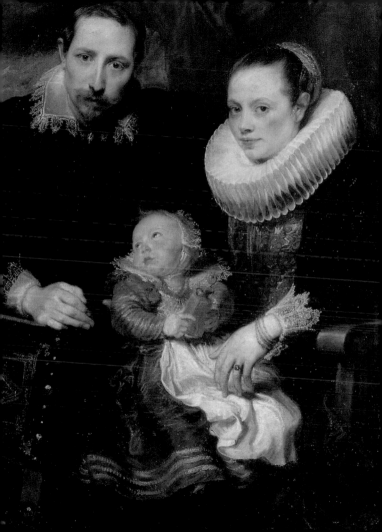

My *mother had a great deal of trouble*
with me, but I think she enjoyed it.

Mark Twain

Jacob Jordaens, *Self-Portrait with Family*,
1621–1622, Museo Nacional del Prado, Madrid.

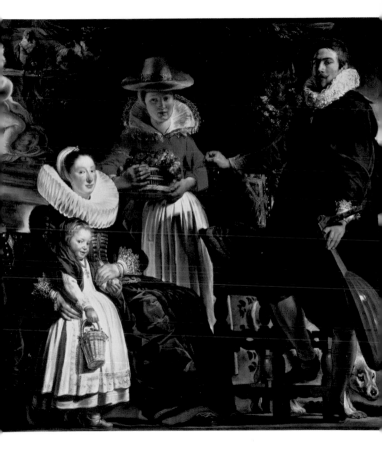

My mother was the most beautiful
woman I ever saw. All I am I owe to my
mother. I attribute all my success in life
to the moral, intellectual, and physical
education I received from her.

George Washington

Anthony van Dyck, *Bettina Balbi Durazzo (La Dama d'Oro)*, detail, 1621–1622, private collection.

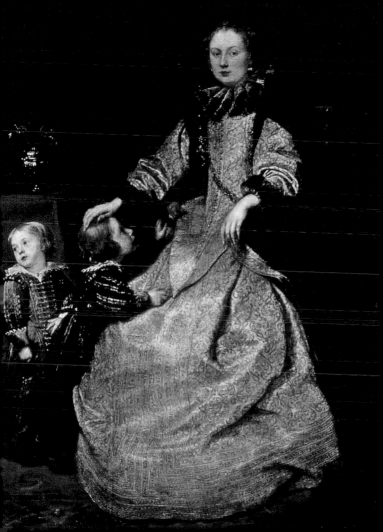

A mother's love endures through all; in good repute, in bad repute, in the face of the world's condemnation, a mother still loves on.

Washington Irving

Cristoforo Martinolio, called il Rocca, *Mother and Child*, detail from *The Healing of the Paralytic*, 1622, Sacro Monte of Varallo (near Vercelli), Italy.

Even as a mother who by noise is wakened,
And close beside her sees the enkindled
 flames,
Who takes her son, and flies, and does
 not stop,
Having more care of him than of herself,
So that she clothes her only with a shift.

Dante Alighieri

Anthony van Dyck, *Rest on the Flight into Egypt*,
1627–1632, Alte Pinakothek, Munich, Germany.

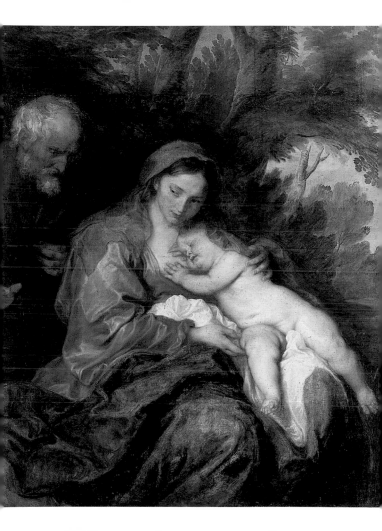

*T*he woman is weak,
but the mother is
strong.

Korean proverb

Orazio Gentileschi, *Rest on the
Flight into Egypt*, 1628, Musée
du Louvre, Paris.

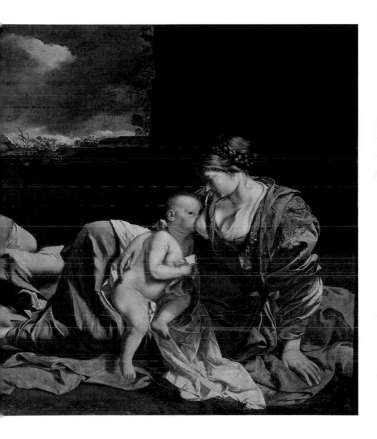

A man who has been the indisputable favorite of his mother keeps for life the feeling of conqueror, that confidence of success that often induces real success.

Sigmund Freud

Peter Paul Rubens, *Helene Fourment with Her Eldest Son Frans*, 1635, Alte Pinakothek, Munich, Germany.

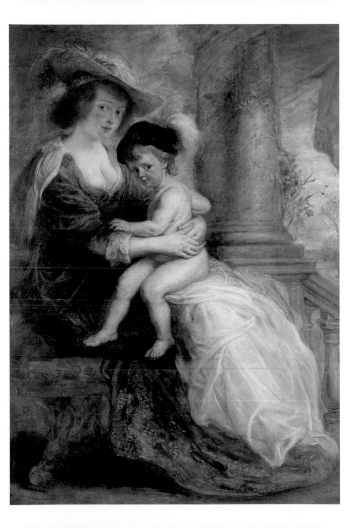

When a woman is twenty, a child deforms her; when she is thirty, he preserves her; and when forty, he makes her young again.

Leon Blum

Jacob Jordaens, *As the Old Sing, So Pipe the Young*, 1638, Royal Museum of Fine Arts, Antwerp, Belgium.

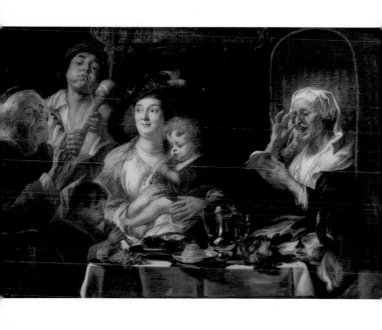

A mother's happiness is like a beacon, lighting up the future but reflected also on the past in the guise of fond memories.

Honoré de Balzac

Francisco de Zurbarán, *Christ and the Virgin in the House at Nazareth*, 1640, Cleveland Museum of Art, Cleveland.

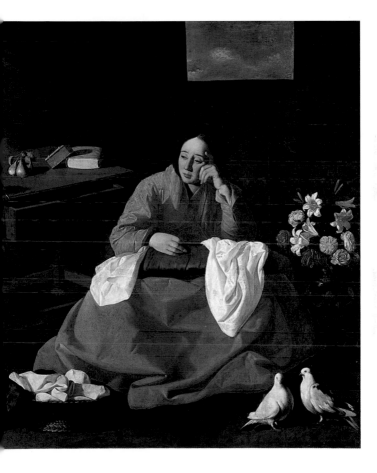

Bread and a little milk are victories, / A warm home . . . is a battle won!

Bertolt Brecht

Louis Le Nain, *The Hay Wagon* or *Return from the Hay Harvest*, 1641, Musée du Louvre, Paris.

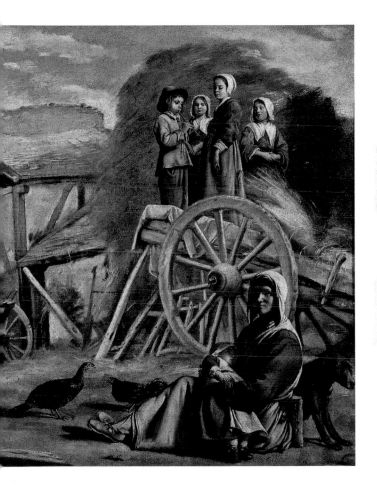

O son, my son, my son!
Of lilies loveliest one!
Help, counsellor is none
For my heart distressed.

Son, with sweet eyes that smiled
Where now Thine answers mild?
Why dost Thou hide, my child,
From Thy Mother's breast?

Jacopone da Todi

Georges de La Tour, *The Newborn*, ca. 1645–1648,
Musée des Beaux-Arts, Rennes, France.

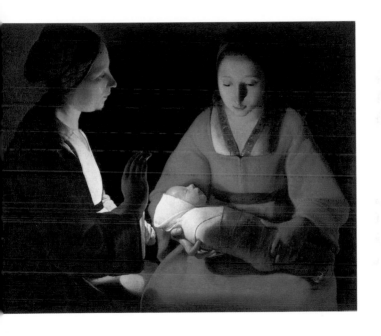

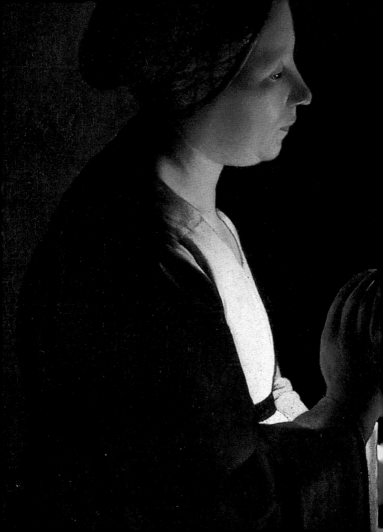

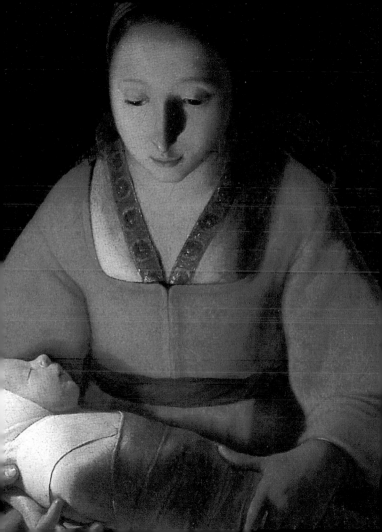

Because when a mother kisses her beloved child, she also kisses the love from which it was born.

Ramón de Campoamor

Rembrandt van Rijn, *The Holy Family with a Curtain*, 1646, Gemäldegalerie, Kassel, Germany.

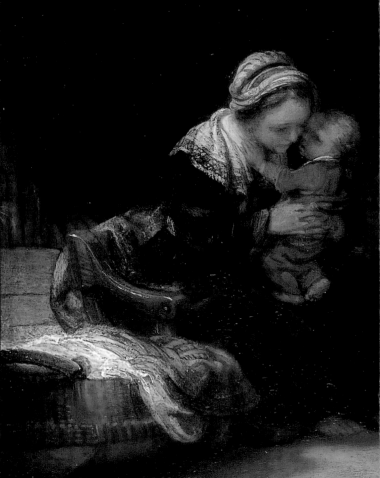

My mother bids me bind my hair
With bands of rosy hue,
Tie up my sleeves with ribbons rare,
And lace my bodice blue.

Anne Hunter

Pieter de Hooch, *Courtyard of a Dutch House*,
1650–1675, Musée du Louvre, Paris.

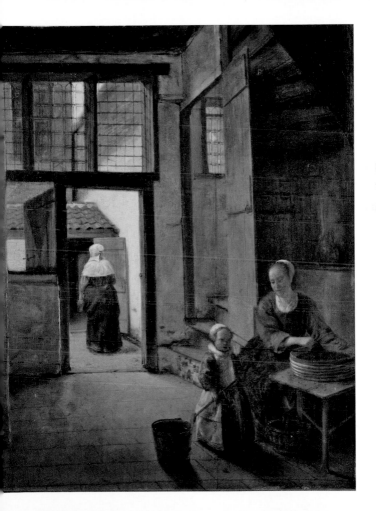

*M*others *always forgive;*
that is why they exist.

Alexandre Dumas (*père*)

Nicolaes Maes, *The Naughty Drummer*, 1654–1659,
Thyssen-Bornemisza Museum, Madrid.

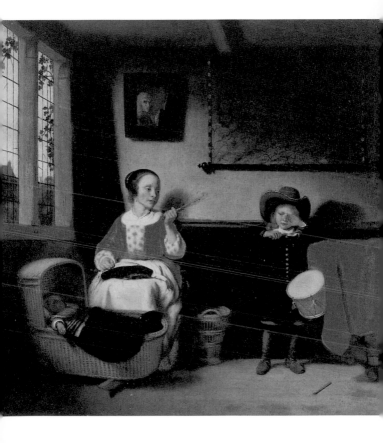

Hearken unto thy father that begat thee, and despise not thy mother when she is old.

Proverbs 23:22

Gerard ter Borch, *Gallant Conversation*, also known as *The Paternal Admonition*, 1654–1660, Rijksmuseum, Amsterdam, the Netherlands.

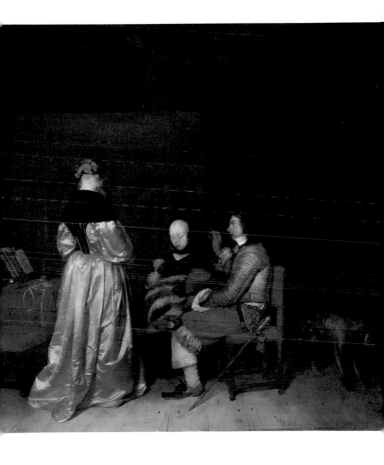

*O*ne good mother is worth a hundred schoolmasters.

George Herbert

Pieter de Hooch, *The Courtyard of a House in Delft*, 1658, National Gallery, London.

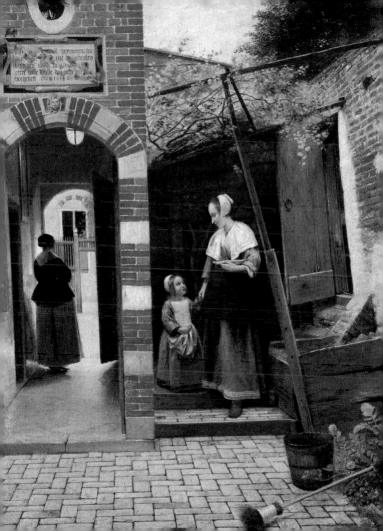

What a mother sings to the cradle goes all the way down to the coffin.

Henry Ward Beecher

Gerrit Dou, *The Young Mother*, 1658, Mauritshuis (Royal Gallery), The Hague.

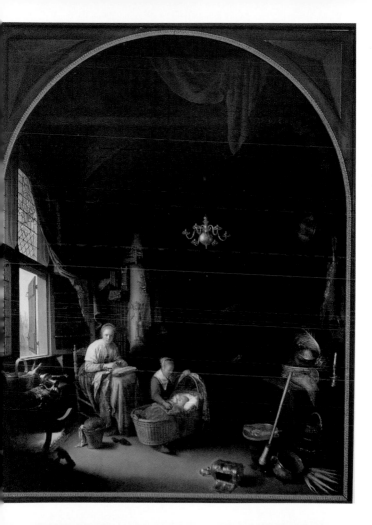

That best academy, a mother's knee.

James Russell Lowell

Gerard ter Borch, *Die Apfelschälerin (Woman Peeling an Apple)*, ca. 1600, Kunsthistorisches Museum, Vienna.

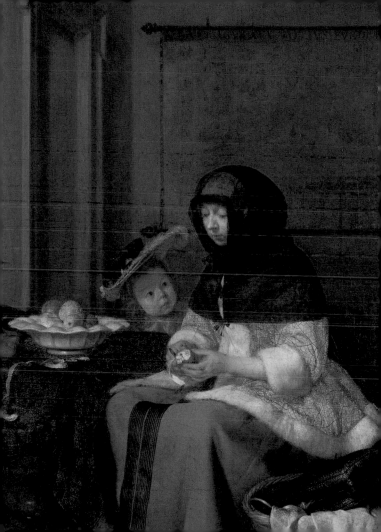

A mother is she who can take the place of all others but whose place no one else can take.

Gaspard Mermillod

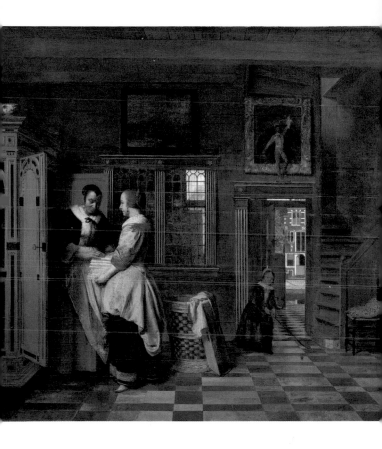

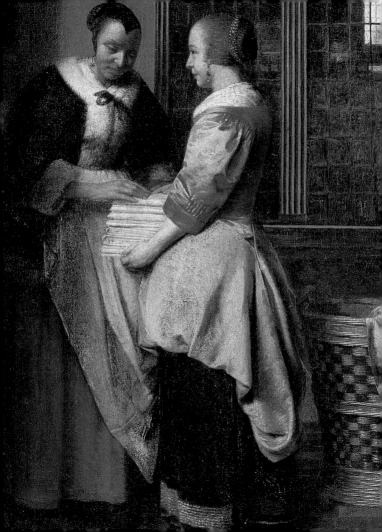

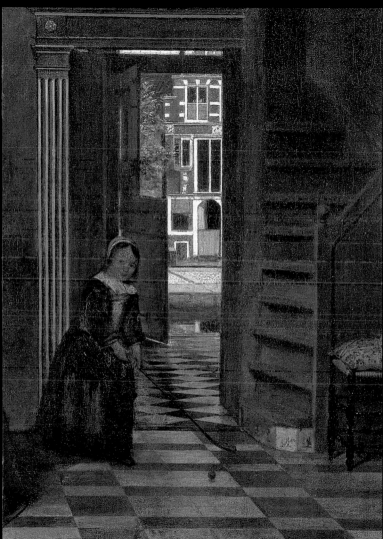

A mother is a mystery.
She understands all, forgives all,
Suffers all, and gives all,
She gathers no flowers for her laurels.

Francesco Pastonchi

Adriaen van Ostade, *Interior with Peasants*, 1663,
Wallace Collection, London.

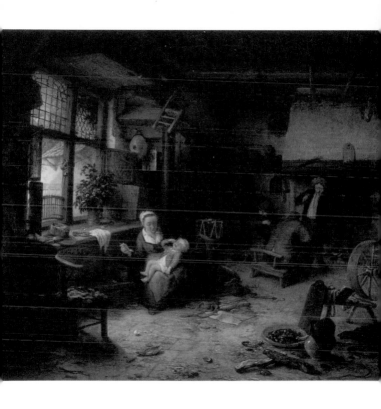

O mother, lay your hand on my brow!
O mother, mother, where am I now?
Why is the room so gaunt and great?
Why am I lying awake so late?

Robert Louis Stevenson

Gabriel Metsu, *The Sick Child*, 1665,
Rijksmuseum, Amsterdam, the Netherlands.

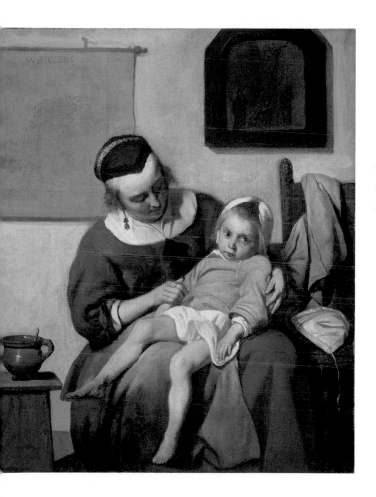

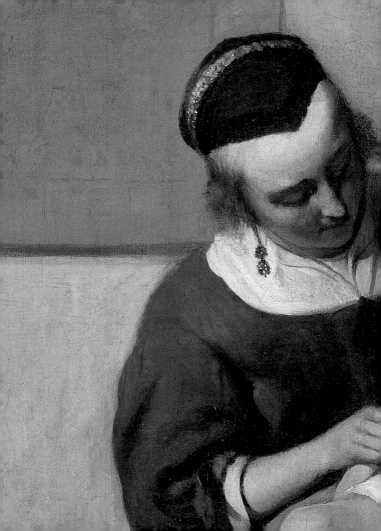

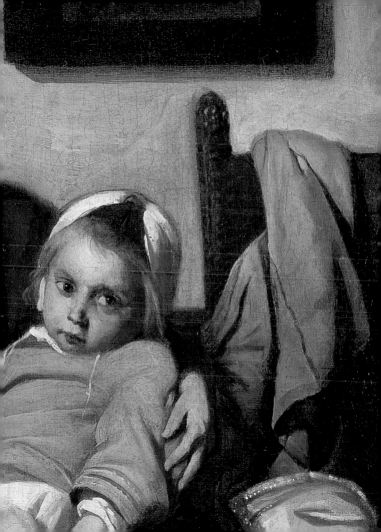

*A*ll women become like their
mothers. That is their tragedy.
No man does. That's his.

Oscar Wilde

Pierre Mignard, *Maria Theresa of Austria*, 1665,
Museo Nacional del Prado, Madrid.

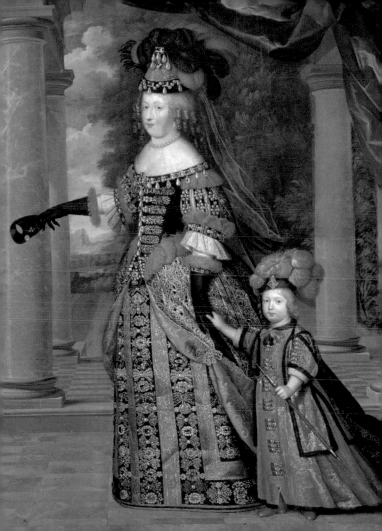

A good mother makes a good daughter.

Henry Ward Beecher

Bartolomé Esteban Murillo, *St. Anne Instructing the Virgin*, Museo Nacional del Prado, Madrid.

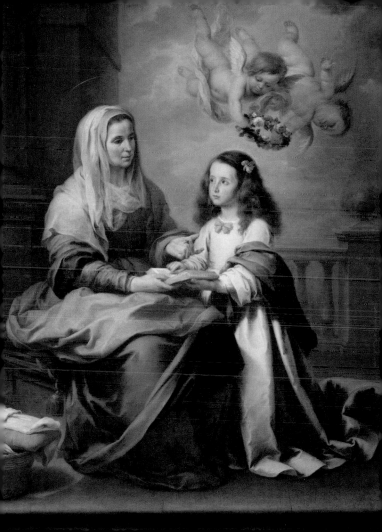

All mothers are rich when they love their children. There are no poor mothers, no ugly ones, no old ones. Their love is always the most beautiful of joys.

Maurice Maeterlinck

Jan Steen, *A Peasant Family at Meal-time ("Grace before Meat")*, ca. 1665, National Gallery, London.

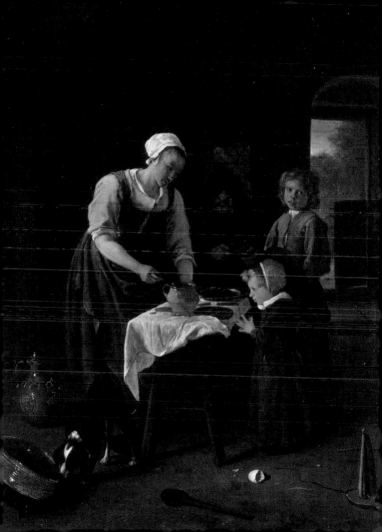

*Mothers, of course, are all right.
They pay a chap's bills and don't
bother him. But fathers bother a
chap and never pay his bills.*

Oscar Wilde

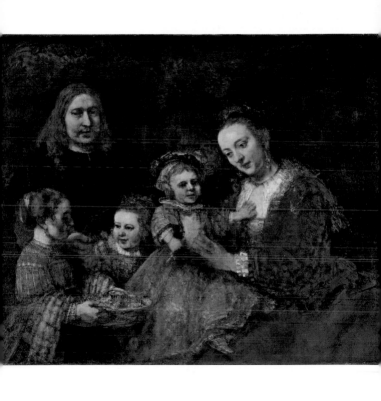

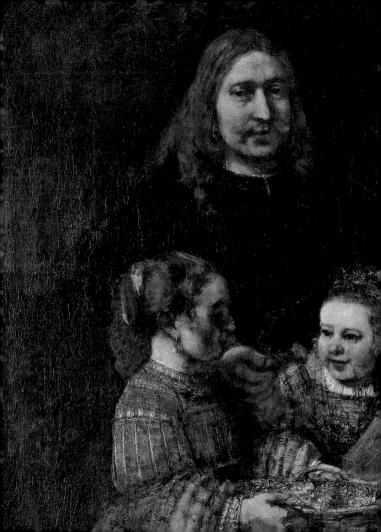

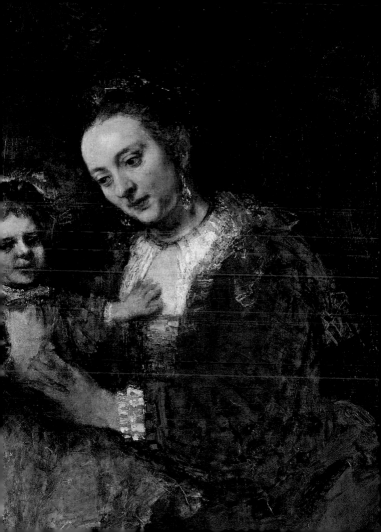

*Are you there, my
 mother?
Because I can't seem
 to see you . . .
I am here, in your
 sleep.*

Miguel de Unamuno

Pieter de Hooch, *Suckling
Mother and Maid*, 1670–1675,
Kunsthistorisches Museum,
Vienna.

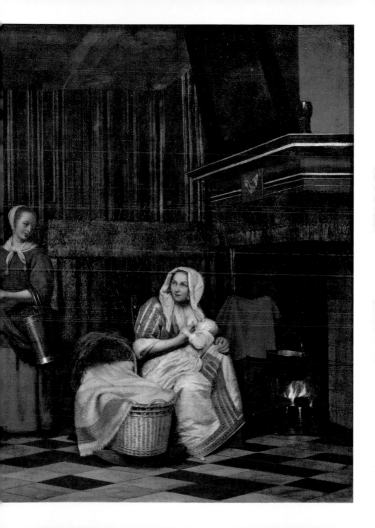

A mother is a mother still,
The holiest thing alive.

Samuel Taylor Coleridge

Johann Kupetzky, *Self-Portrait with Wife and Child*,
ca. 1705, Museum of Fine Arts (Szépmûvészeti
Múzeum), Budapest, Hungary.

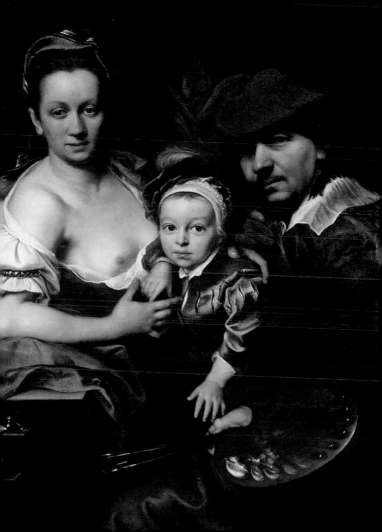

*F*or this my mother wrapped me warm,
And called me home against the storm,
And coaxed my infant nights to quiet,
And gave me roughage in my diet,
And tucked me in my bed at eight,
And clipped my hair, and marked my weight,
And watched me as I sat and stood:
That I might grow to womanhood.

Dorothy Parker

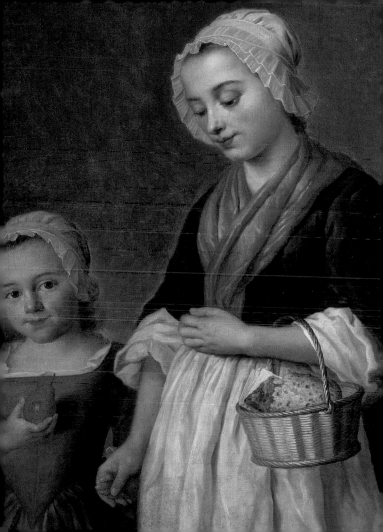

*If you ask your mother for one fried egg
 for breakfast and she
gives you two fried eggs and you eat both
 of them, who is
better in arithmetic, you or your mother?*

Carl Sandburg

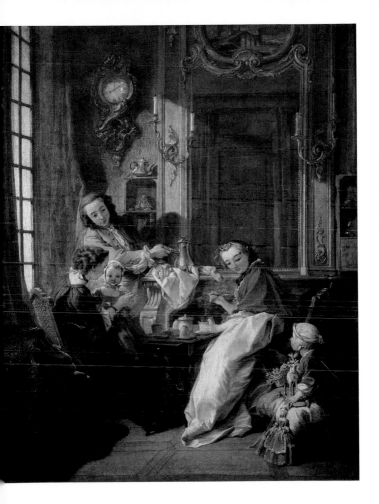

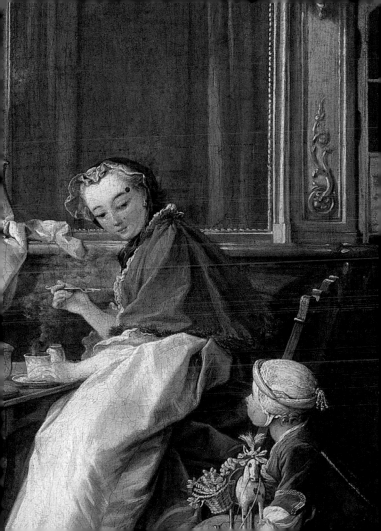

Where there is a mother in the home, matters go well.

Amos Bronson Alcott

Jean-Baptiste-Siméon Chardin, *The Prayer before Meal*, 1740, Musée du Louvre, Paris.

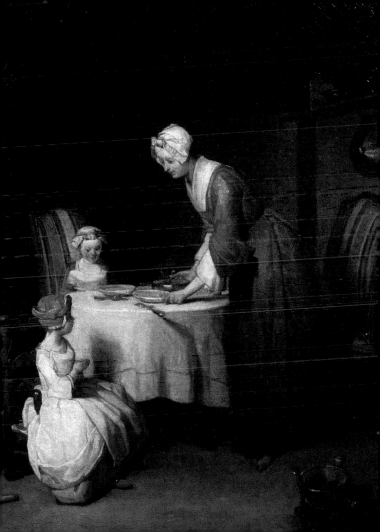

She tried in every way to understand me, and she succeeded. It was this deep, loving understanding as long as she lived that more than anything else helped and sustained me on my way to success.

Mae West

Gaspare Traversi, *Maternal Pride*, detail, ca. 1750, private collection.

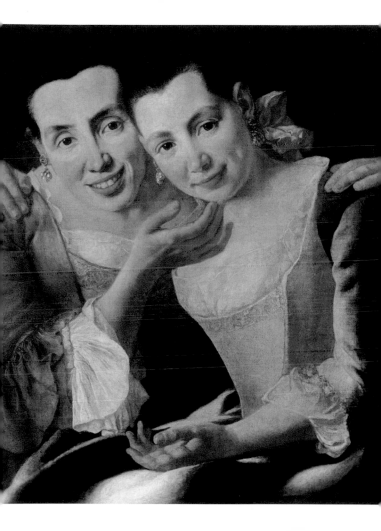

The watchful mother tarries nigh, though sleep has closed her infant's eyes.

John Keble

Gaspare Traversi, *Motherhood*, ca. 1750, private collection.

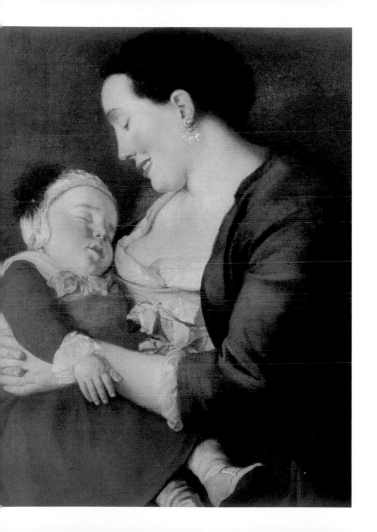

*T*hou art thy mother's glass, and she in thee
Calls back the lovely April of her prime.

William Shakespeare

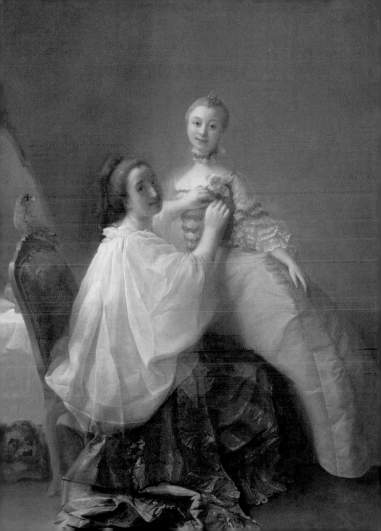

A mother's anger never lasts more than one night.

African proverb

Ivan Ivanovich Firsov, *The Young Painter*,
ca. 1760, State Tretyakov Gallery, Moscow.

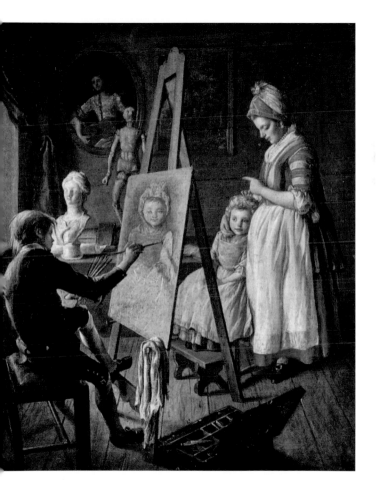

When all the children sleep
She turns as long away
As will suffice to light her lamps;
Then, bending from the sky

With infinite affection
And infiniter care,
Her golden finger on her lip,
Wills silence everywhere.

Emily Dickinson

Joshua Reynolds, *Virgin and Child,*
ca. 1765, private collection.

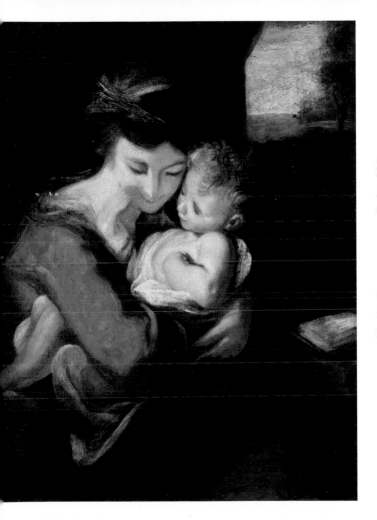

*W*hen God thought of Mother, *he must have laughed with satisfaction, and framed it quickly,—so rich, so deep, so divine, so full of soul, power, and beauty was the conception.*

Henry Ward Beecher

Benjamin West, *William Penn's Treaty with the Indians*, 1771–1772, Pennsylvania Academy of the Fine Arts, Philadelphia.

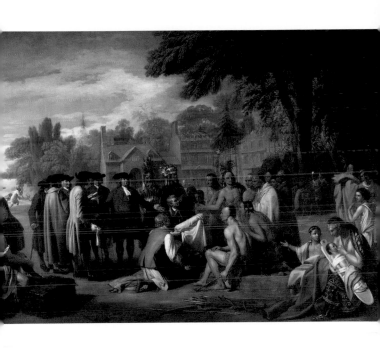

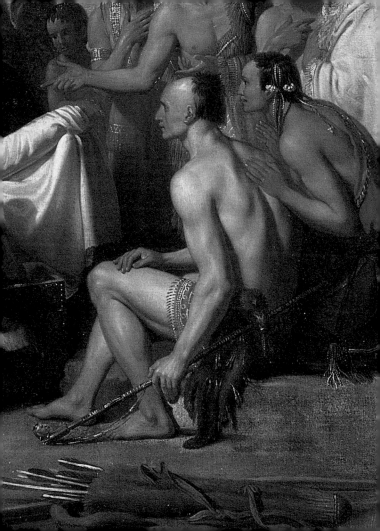

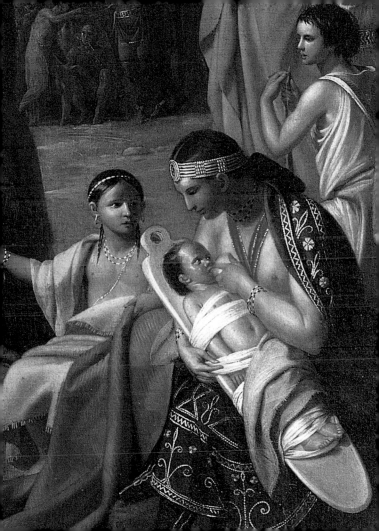

With what price we pay for the glory of motherhood.

Isadora Duncan

Kitagawa Utamaro, *Mother and Child*, late eighteenth century, Bibliothèque des Arts Décoratifs, Paris.

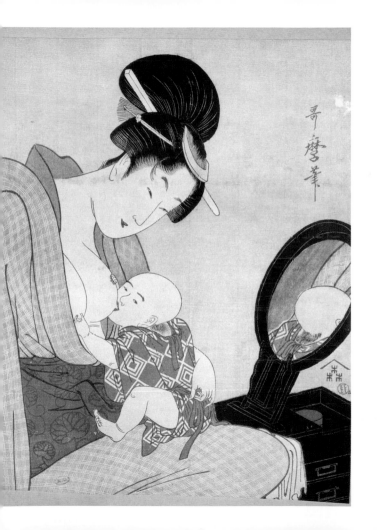

Mama exhorted her children at every opportunity to "jump at de sun." We might not land on the sun, but at least we would get off the ground.

Zora Neale Hurston

Joshua Reynolds, *Georgiana, Duchess of Devonshire, and Her Daughter*, 1784–1786, Chatsworth House, Derbyshire.

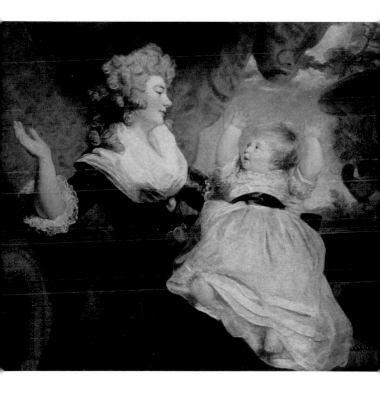

A mother is not a person to lean on, but a person to make leaning unnecessary.

Dorothy Canfield Fisher

Adélaïde Labille-Guiard, *Portrait of Louise-Elisabeth de France, Duchess of Parma, and Her Son Ferdinand*, 1788, Versailles, Trianon.

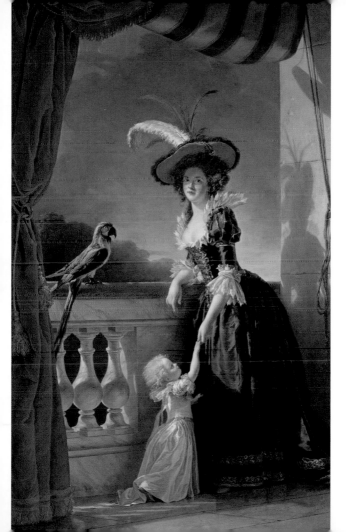

O daughter, more charming than your charming mother.

Horace (Quintus Horatius Flaccus)

Élisabeth-Louise Vigée-Lebrun, *Madame Vigée-Lebrun and Her Daughter Jeanne Lucie Louise*, 1789, Musée du Louvre, Paris.

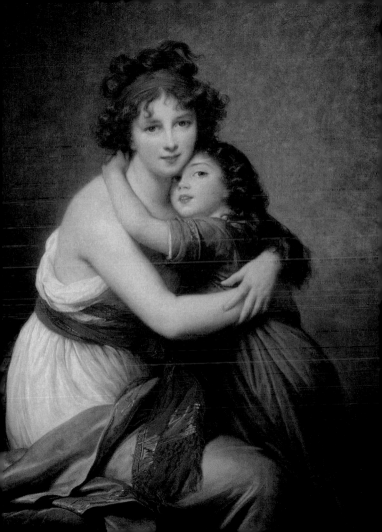

I think it must somewhere be written
that the virtues of mothers shall,
occasionally, be visited on their children.

Charles Dickens

Antonio Canova, *Teach the Ignorant and Feed the
Hungry*, detail, 1795–1796, Museo Correr, Venice.

A man loves his sweetheart the most, his wife the best, but his mother the longest.

Irish proverb

Constance Marie Mayer-Lamartiniere, *The Happy Mother*, 1795–1805, Musée du Louvre, Paris.

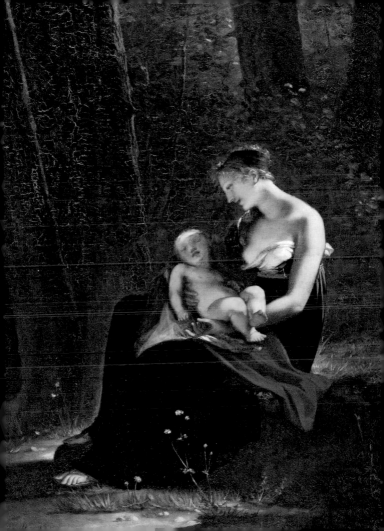

*B*egin, little lad, to recognize mother
with a smile.

Virgil (Publius Vergilius Maro)

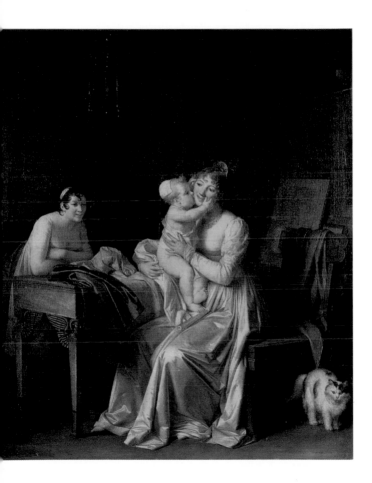

*T*hough motherhood is the most important of all the professions—requiring more knowledge than any other department in human affairs—there was no attention given to preparation for this office.

Elizabeth Cady Stanton

Katsushika Hokusai, *Woman Giving Birth*, 1817, Edoardo Chiossone Museum of Oriental Art, Genoa.

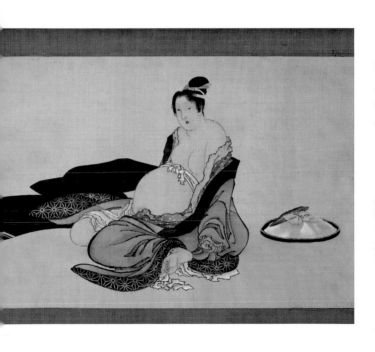

My mother groan'd, my father wept,
Into the dangerous world I leapt,
Helpless, naked, piping loud,
Like a fiend hid in a cloud.

William Blake

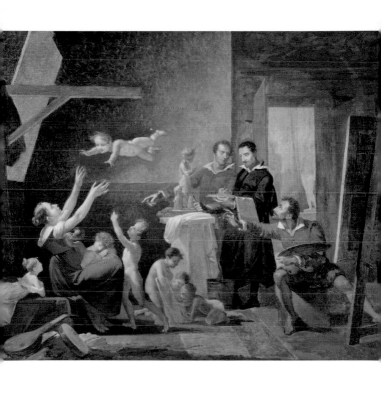

The child calls his mother and asks:
"Where did I come from, Mother?
Where did you find me?"

The mother smiles and cries,
Takes the child in her arms and says:
"You were the desire in my heart!"

Rabindranath Tagore

Karoly Brocky, *Mother and Child*, 1846–1850, Museum of Fine Arts (Szépmûvészeti Múzeum), Budapest, Hungary.

The mother is the most precious possession of the nation, so precious that society advances its own highest well-being when it protects the functions of the mother.

Ellen Key

Honoré Daumier, *La République (The Republic)*, 1848, Musée d'Orsay, Paris.

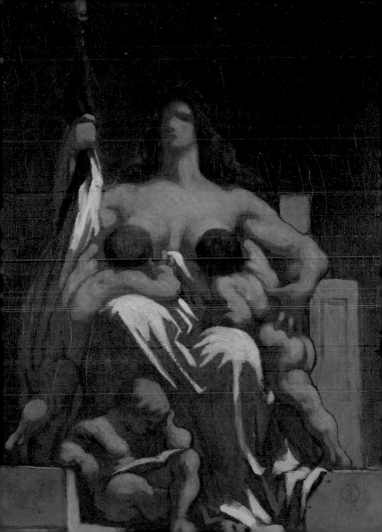

*Y*et despite the true pride pure blood may occasion, a mother's guilt is still a heavy burden.

Jean-Baptiste Racine

Honoré Daumier, *The Burden*, ca. 1855,
Bibliothèque Nationale de France, Paris.

One thing remember, my girls. Mother is always ready to be your confidante, Father to be your friend, and both of us hope and trust that our daughters, whether married or single, will be the pride and comfort of our lives.

Louisa May Alcott

Edgar Degas, *The Bellelli Family*, 1858, Musée d'Orsay, Paris.

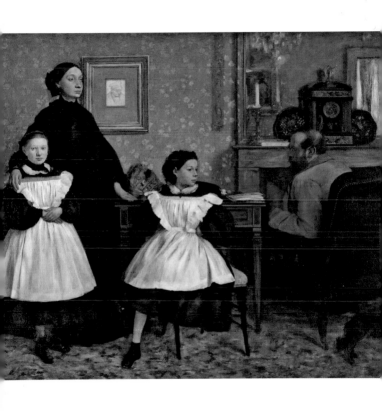

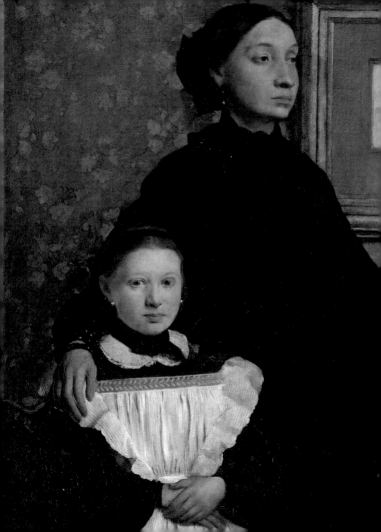

She broke the bread into two fragments, and gave them to the children, who ate with avidity.

"She has kept none for herself," grumbled the sergeant.

"Because she is not hungry," said a soldier.

"Because she is a mother," said the sergeant.

Victor Hugo

Jean-François Millet, *Feeding the Young*, ca. 1860,
Palais des Beaux-Arts, Lille.

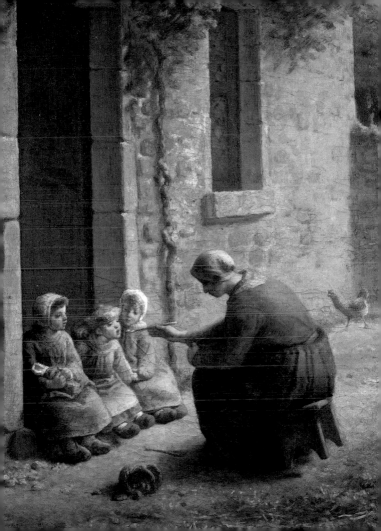

There is no influence so powerful as that of the mother.

Sarah Josepha Hale

Honoré Daumier, *The Laundress*, detail,
ca. 1863, Musée d'Orsay, Paris.

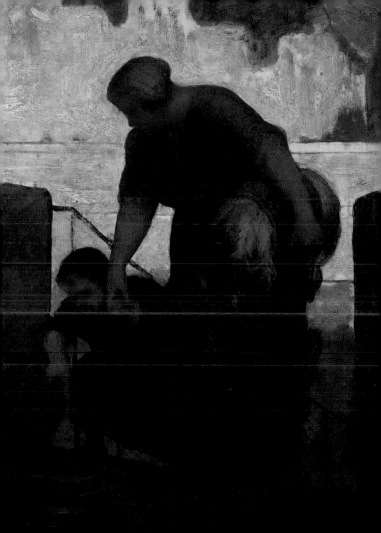

Those who refused to see in Whistler any other good quality could not deny his devotion to his mother; those to whom he revealed the tenderness, under the defiant masque with which he faced the world, knew what his love for her meant to him.

Joseph Pennell

James Abbott McNeill Whistler, *Arrangement in Grey and Black No. 1*, also called *Portrait of the Artist's Mother*, 1871, Musée d'Orsay, Paris.

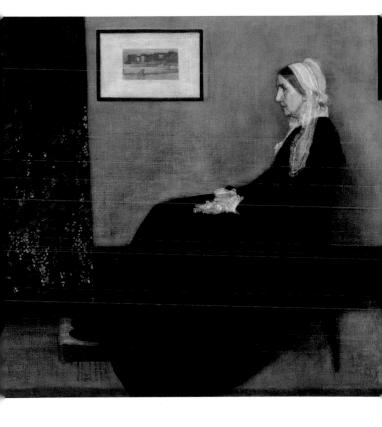

For *the hand that rocks the cradle*
Is the hand that rules the world.

William Ross Wallace

Berthe Morisot, *Le berceau (The Cradle)*, 1872,
Musée d'Orsay, Paris.

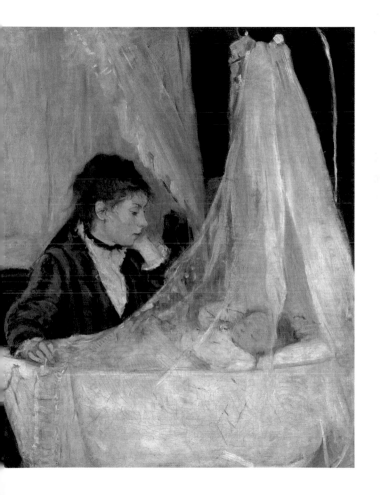

If there were no curiosity, little would be done for the good of one's neighbor. But, under the name of Duty or Sympathy, Curiosity creeps into the house of the unfortunate and needy.—Perhaps even in the much celebrated maternal love is to be found a bit of Curiosity.

Friedrich Nietzsche

Tranquillo Cremona, *Mother Love*, 1873,
Gallery of Modern Art, Milan.

*N*obody can have the soul of me. My mother has had it, and nobody can have it again.

D. H. Lawrence

Silvestro Lega, *The Visit of the Nursemaid*, 1873, Gallery of Modern Art, Florence.

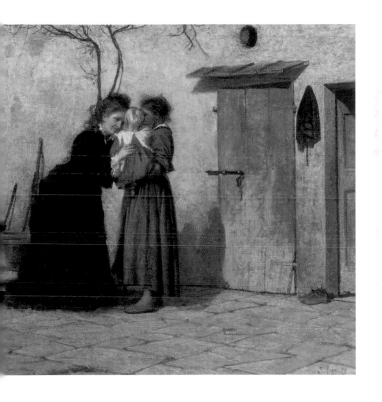

See all the children gathered there,
Their mother near; so young, so fair,
An elder sister she might be,
And yet she hears, amid their games,
The shaking of their unknown names
In the dark urn of destiny.

Victor Hugo

Aimé-Jules Dalou, *Peasant Woman Nursing a Baby*,
Bethnal Green Museum of Childhood, London.

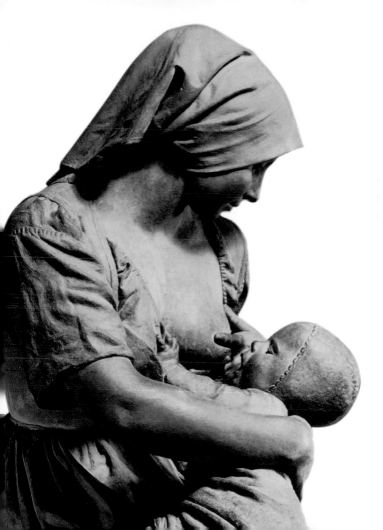

Oh, *the comfort, the inexpressible comfort of feeling safe with a person, having neither to weigh thoughts nor measure words, but pouring them all out, just as they are, chaff and grain together, certain that a faithful hand will take and sift them, keep what is worth keeping, and with a breath of kindness blow the rest away.*

George Eliot

Claude Monet, *Poppy Field at Argenteuil*, 1873, Musée d'Orsay, Paris.

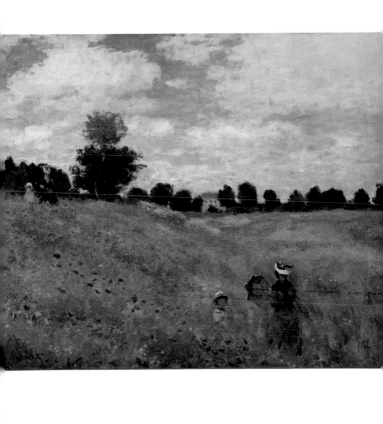

I *want a mom that will last forever*
I want a mom to make it all better
I want a mom that will last forever
I want a mom who will love me whatever.

Cyndi Lauper and Mark Mothersbaugh

Berthe Morisot, *Chasse aux papillons (Chasing Butterflies)*, 1874, Musée d'Orsay, Paris.

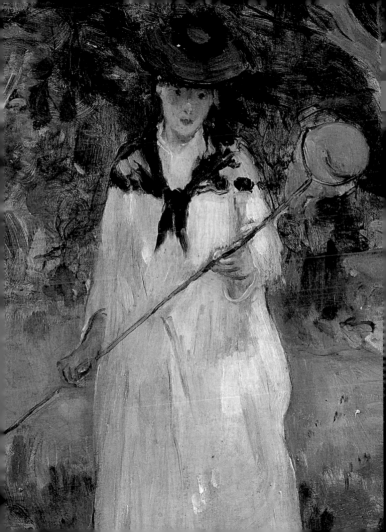

In talking to children, the old Lakota would place a hand on the ground and explain: "We sit in the lap of our Mother. From her we, and all other living things, come. We shall soon pass, but the place where we now rest will last forever." So we, too, learned to sit or lie on the ground and become conscious of life about us in its multitude of forms.

Chief Luther Standing Bear

William de la Montagne Cary, *Indian Mother and Child,* Buffalo Bill Historical Center (Whitney Gallery of Western Art Collection), Cody, Wyoming.

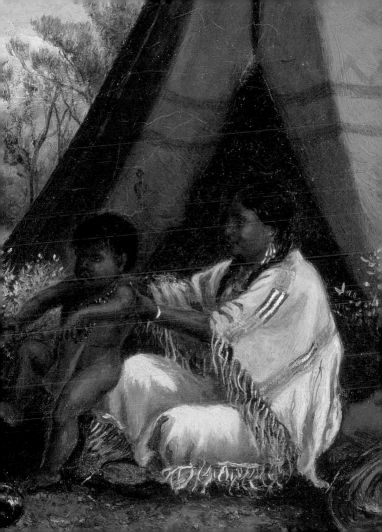

My mother's hands are cool and fair,
They can do anything.
Delicate mercies hide them there
Like flowers in the spring.

Anna Hempstead Branch

Berthe Morisot, *Beneath the Lilac at Maurecourt,*
1874, private collection.

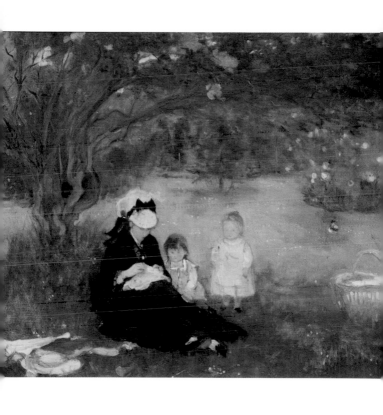

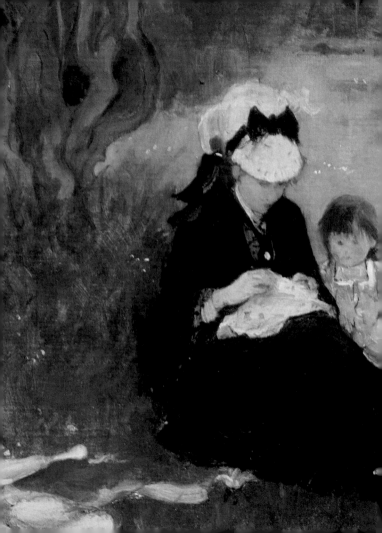

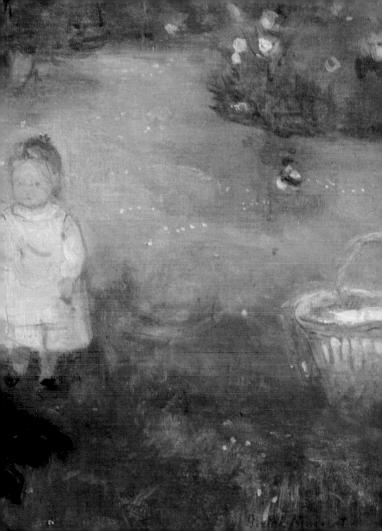

The word mother is hidden in our hearts, and it comes upon our lips in hours of sorrow and happiness as the perfume comes from the heart of the rose and mingles with clear and cloudy air.

Kahlil Gibran

Claude Monet, *Camille Monet and a Child in the Artist's Garden in Argenteuil*, 1875, Museum of Fine Arts, Boston.

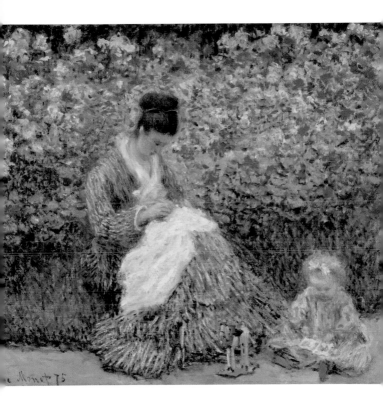

This, then, is she,
My mother as she
 looked at seventeen,
When she first met my
 father. Young
 incredibly,
Younger than spring,
 without the faintest
 trace
Of disappointment,
 weariness, or tean
Upon the childlike
 earnestness and grace
Of the waiting face.

William Vaughn Moody

Adriano Cecioni, *The Mother*,
1878, Palatine Gallery, Pitti
Palace, Florence.

I had a Mother who read me things
That wholesome life to a child's
* heart brings —*
Stories that stir with an upward touch.
Oh that every Mother were such!

You may have tangible wealth untold
Caskets of jewels and coffers of gold.
Richer than I you can never be.
I had a Mother who read to me.

Strickland Gillilan

George Dunlop Leslie, *Alice in Wonderland*, 1879, Royal
Pavilion, Libraries and Museums, Brighton, England.

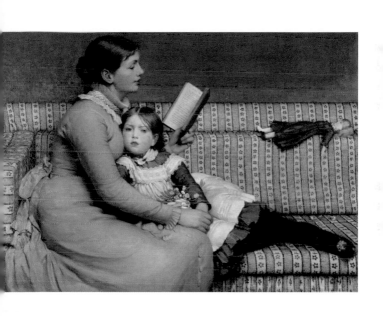

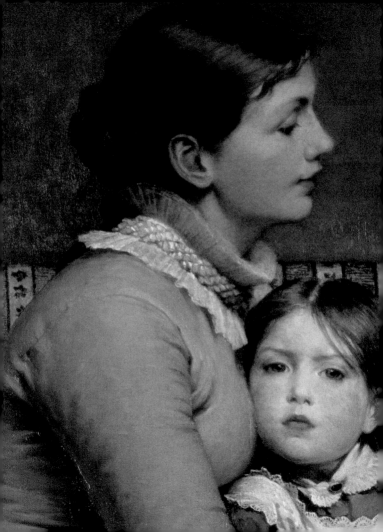

Long, long before the Babe could speak,
When he would kiss his mother's cheek
* And to her bosom press,*
The brightest angels standing near
Would turn away to hide a tear—
For they are motherless.

John Banister Tabb

Mary Cassatt, *Mother About to Wash Her Sleepy Child*,
1880, Los Angeles County Museum of Art, Los Angeles.

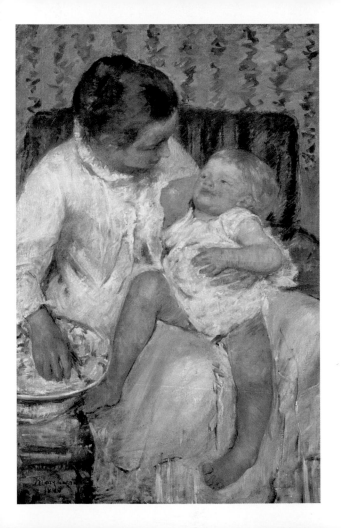

*E*ducation commences at the mother's knee, and every word spoken within hearsay of little children tends toward the formation of character.

Hosea Ballou

Silvestro Lega, *Lesson with Grandmother*, ca. 1881,
Palazzo Municipale (Town Hall), Peschiera del
Garda (near Verona), Italy.

Ding, Dong, the bells tell me: Sleep!
They sing: Go to sleep! They whisper:
 Sleep! They hum: Go to sleep! There,
 voices of light-blue shadows. . . .
They seem like lullabies, taking me back to
 who I once was . . . I heard my mother's
 voice . . . then nothing as night falls.

Giovanni Pascoli

Teofilo Patini, *Vanga e Latte (Spade and Milk)*,
1884, Ministry of Agriculture and Forests, Rome.

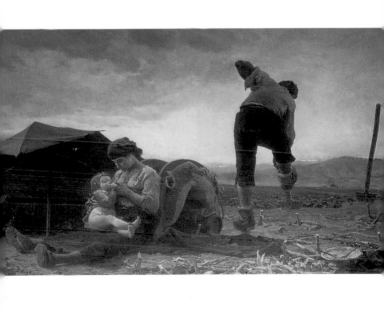

The aunts, the mothers and the sisters have a particular jurisprudence for their nephews, their sons and their brothers.

Honoré de Balzac

Hugo Fredrik Salmson, *The Dalby Gate, Skane*, 1884, Musée d'Orsay, Paris.

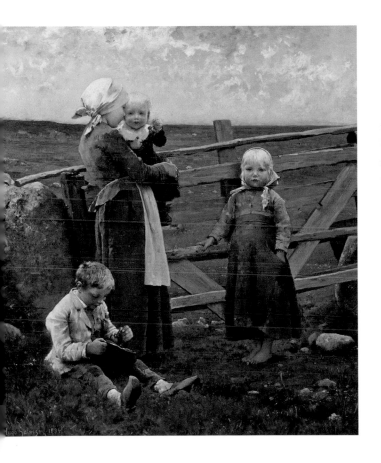

You're the only one in the world
 who knows
what my heart always held, before
 all other love.

Pier Paolo Pasolini

Giuseppe De Nittis, *Lunch in the Garden*, 1884,
Museo De Nittis, Barletta (near Bari), Italy.

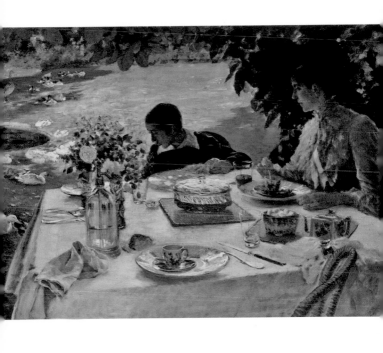

*The bravest battle
that ever was
fought;
Shall I tell you where
and when?
On the maps of the
world you will find
it not;
It was fought by the
mothers of men.*

Joaquin Miller

Charles Frederic Ulrich, *In the
Land of Promise, Castle Garden*,
1884, Corcoran Gallery,
Washington, D.C.

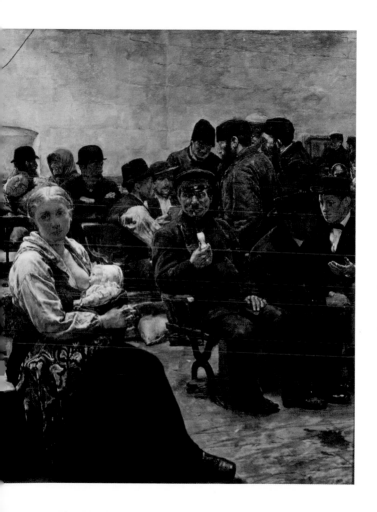

I was one of the luckier women, I came to motherhood with some experience. I owned a Yorkshire terrier for three years. At 10 months, my children could stay and heel. At a year, they could catch a Frisbee in their teeth in midair. At 15 months, after weeks of rubbing their noses in it and putting them outside, they were paper-trained.

Erma Bombeck

Georges Seurat, *A Sunday on La Grande Jatte—1884*, 1884–1886, The Art Institute of Chicago.

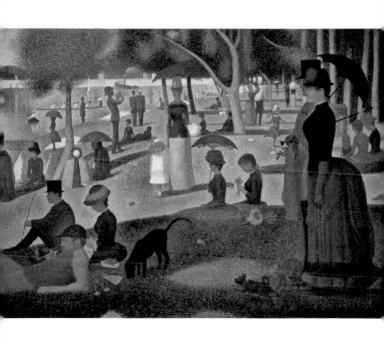

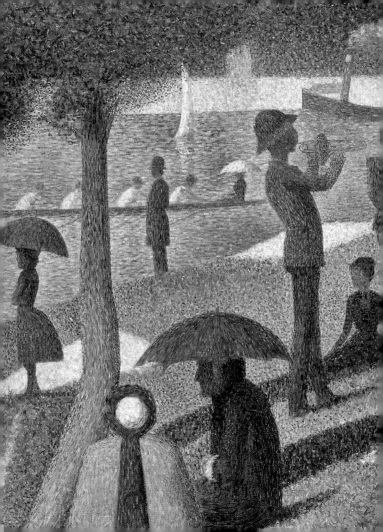

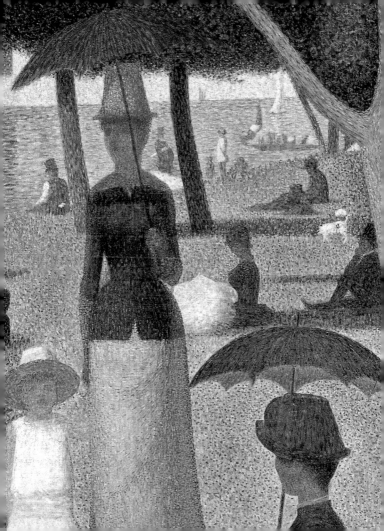

*T*he garment of Surprise
Was all our timid Mother wore
At Home, in Paradise.

Emily Dickinson

Pierre-Auguste Renoir, *Maternity,* also called
Child at the Breast, 1885, Musée d'Orsay, Paris.

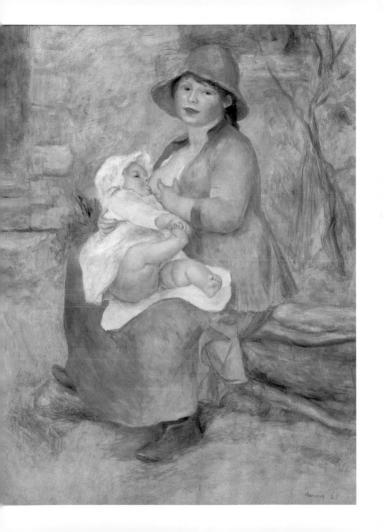

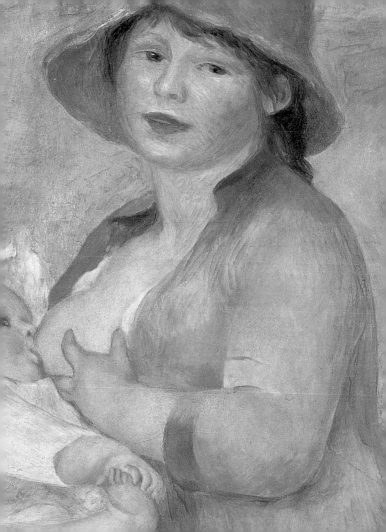

A family can develop only with a loving woman as its center.

Karl Wilhelm Friedrich Schlegel

Constant Aimé Marie Cap, *Mother's Day*, 1885, private collection.

The sea is never still.
It pounds on the shore
Restless as a young heart,
Hunting.

The sea speaks
And only the stormy hearts
Know what it says:
It is the face
of a rough mother speaking.

Carl Sandburg

Giovanni Segantini, *Ave Maria a Trasbordo*,
detail, 1886, Otto Fischbacher Collection,
St. Gallen, Switzerland.

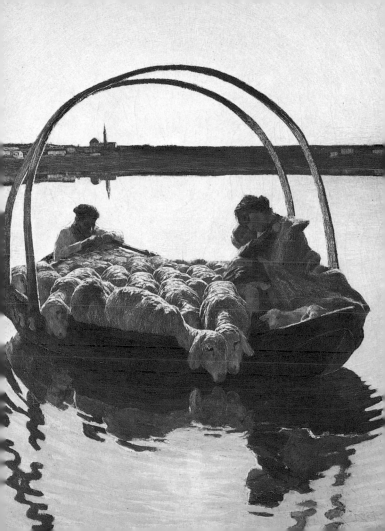

I watch from my blanket on the grass
As my mother's blouses lift and billow,
Bursting with the day.

George Bilgere

Camille Pissarro, *Woman Hanging Her Laundry*,
1887, Musée d'Orsay, Paris.

*M*otherhood meant *I have written four fewer books, but I know more about life.*

A. S. Byatt

Michael Ancher, *Anna Ancher with Her Daughter Helga*, Skagensmuseum, Skagens, Denmark.

My mother taught me that every night a procession of junks carrying lanterns moves silently across the sky, and the water sprinkled from their paddles falls to the earth in the form of dew.

Allen Upward

Gaetano Previati, *Peace*, or *Morning*, 1889, Gallery of Modern Art, Florence.

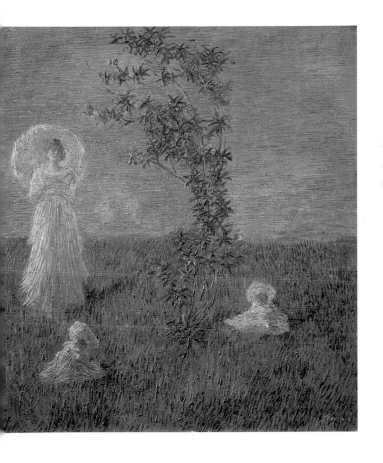

There's a song in the air!
There's a star in the sky!
There's a mother's deep prayer
And a baby's low cry!

Josiah Gilbert Holland

Giovanni Segantini, *The Two Mothers*,
1889, Gallery of Modern Art, Milan.

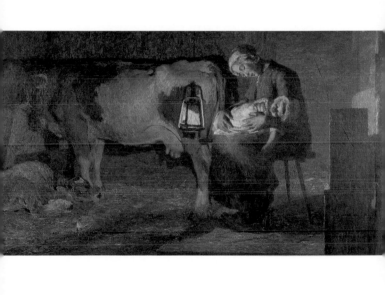

Backward, turn backward, O Time, in
 your flight,
Make me a child again just for to-night!
Mother, come back from the echoless shore,
Take me again to your heart as of yore;
Kiss from my forehead the furrows of care,
Smooth the few silver threads out of my hair;
Over my slumbers your loving watch keep;—
Rock me to sleep, mother,—rock me to sleep!

Elizabeth (Akers) Allen

Eugène Carrière, *Intimacy,* also called *The Big
Sister*, 1889, Musée d'Orsay, Paris.

The most beautiful word on the lips of mankind is the word "Mother," and the most beautiful call is the call of "My mother." . . . She is the source of love, mercy, sympathy, and forgiveness. . . . Every thing in nature bespeaks the mother.

Kahlil Gibran

Paul Gauguin, *Ia Orana Maria (Hail Mary)*, 1891, Metropolitan Museum of Art, New York.

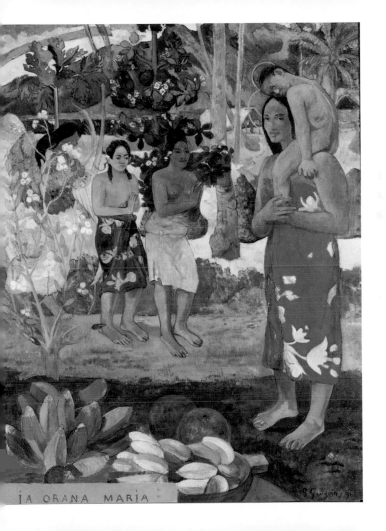

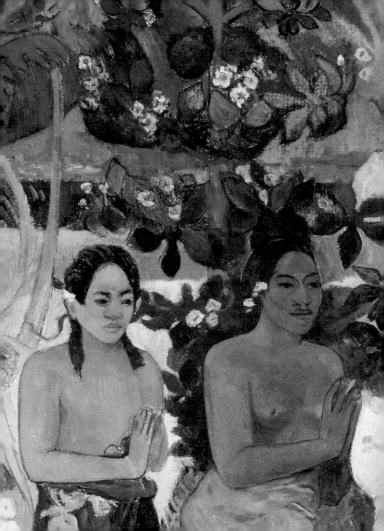

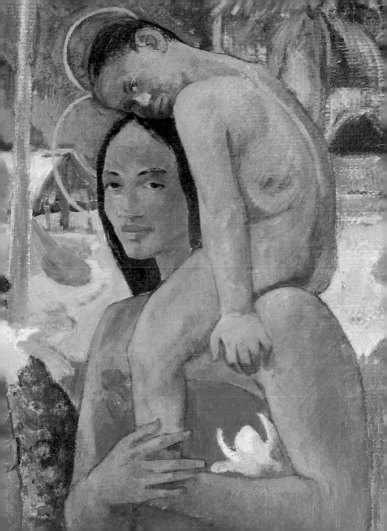

Whatever beauty or poetry is to be found in my little book is owing to your interest in and encouragement of all my efforts from the first to the last; and if ever I do anything to be proud of, my greatest happiness will be that I can thank you for that, as I may do for all the good there is in me; and I shall be content to write if it gives you pleasure.

Louisa May Alcott

Mary Cassatt, *The Child's Bath*, 1893,
The Art Institute of Chicago.

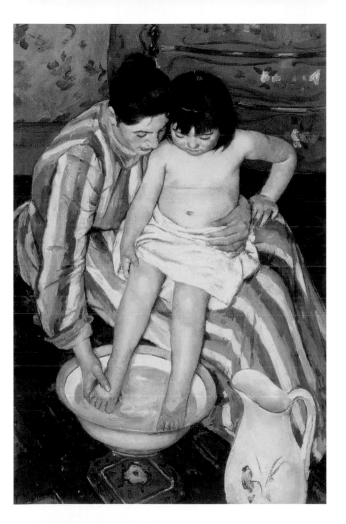

When my mother smiled, her face grew still prettier, and all looked bright around her. If during the most trying moments of my life, I could have caught a glimpse of her smile, I should not have known what grief is.

Leo Tolstoy

Mary Cassatt, *The Boating Party*, 1893–1894,
National Gallery of Art, Washington, D.C.

366

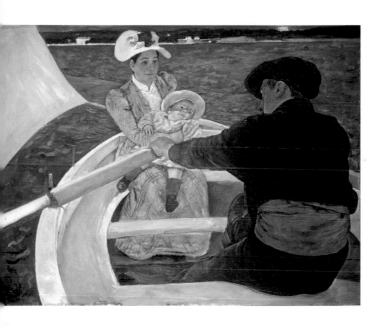

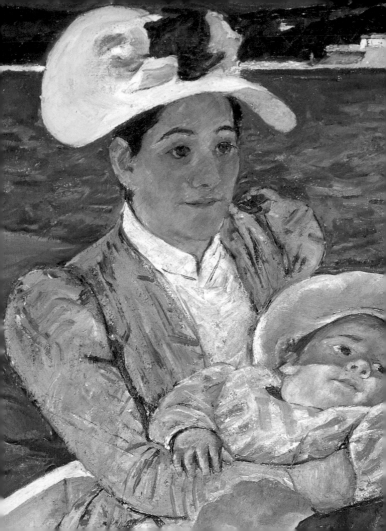

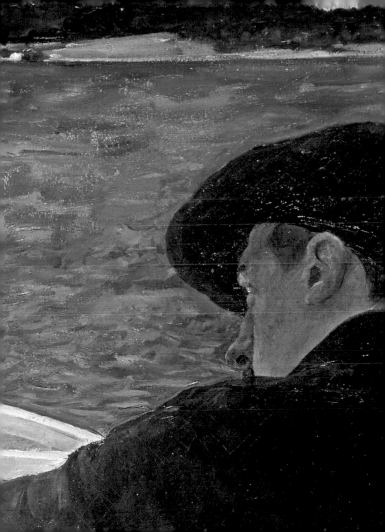

When your mother asks, "Do you want a piece of advice?" it is a mere formality. It doesn't matter if you answer yes or no. You're going to get it anyway.

Erma Bombeck

Edouard Vuillard, *Jardins publics: la conversation, les nourrices, l'ombrelle rouge,* detail, 1894, Musée d'Orsay, Paris.

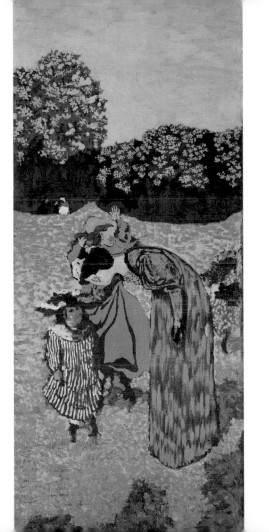

*To feel in our hand once more
the pulse in the good hand
of our mother . . . And to walk
 through life in dreams
out of love for the hand
 that guides us.*

Antonio Machado

Georges d'Espagnat, *La Gare de banlieue (Outlying Train Station)*, 1895, Musée d'Orsay, Paris.

The sweet, soft freshness that blooms
* on baby's limbs—does*
anybody know where it was hidden
* so long?*
Yes, when the mother was
a young girl it lay pervading her heart
in the tender and silent
mystery of love—the sweet, soft freshness
* that has bloomed on*
baby's limbs.

Rabindranath Tagore

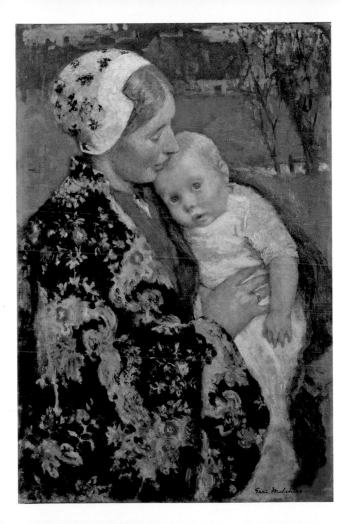

*L*ife began with
waking up and loving
my mother's face.

George Eliot

Joaquín Sorolla y Bastida, *Mother*,
1895, Museo Sorolla, Madrid.

*U*sually a mother loves
herself in her son more than
she loves the son himself.

Friedrich Nietzsche

Medardo Rosso, *Golden Age*, or *Motherhood*,
1896, Gallery of Modern Art, Milan.

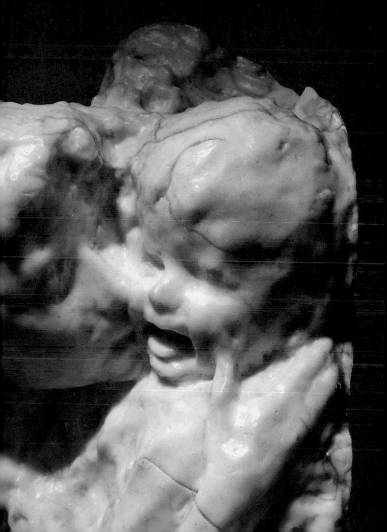

*B*oth nuns and
 mothers worship
 images,
But those the candles
 light are not as those
That animate a
 mother's reveries,
But keep a marble or
 a bronze respose.

William Butler Yeats

Paul Gauguin, *Te Tamari No
Atua (Birth of Christ Son of
God)*, 1896, Neue Pinakothek,
Munich, Germany.

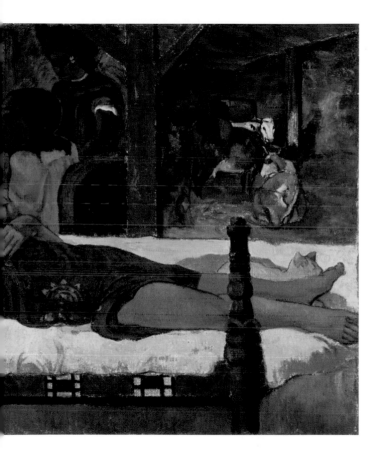

*H*appy chimney-corner days,
Sitting safe in nursery nooks.

Robert Louis Stevenson

Carl Larsson, *The Artist's Wife with Their Daughter Kersti*,
1898, Göteborgs Konstmuseum, Göteborg, Sweden.

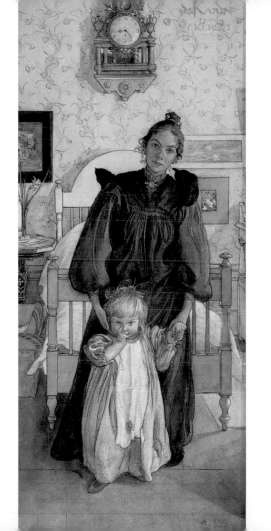

I really learned it all from mothers.

Benjamin Spock

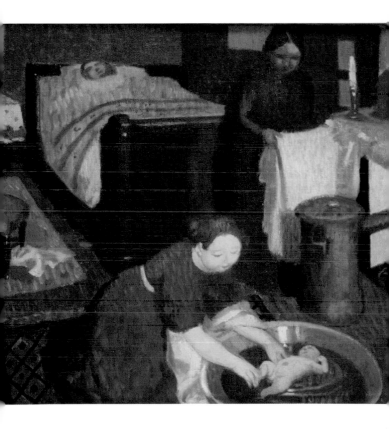

The relationship of parent and child . . . remains indelible and indestructible, the strongest relationship on earth.

Theodor Reik

Mary Cassatt, *Young Mother Sewing*, 1901, The Metropolitan Museum of Art, New York.

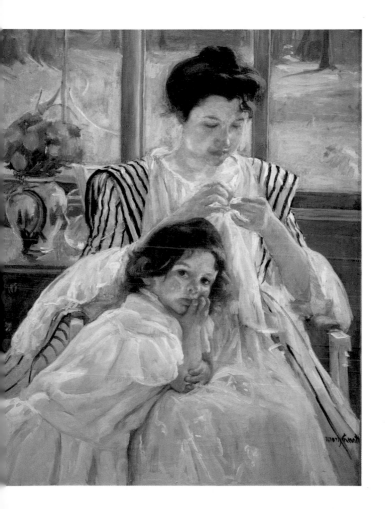

*Said the child, I love you
 more than I know.
She laid her head on her
 mother's arm,
And the love between them
 kept her warm.*

Stevie Smith

John Singer Sargent, *Mrs. Fiske Warren (Gretchen Osgood) and Her Daughter Rachel,* 1903, Museum of Fine Arts, Boston.

390

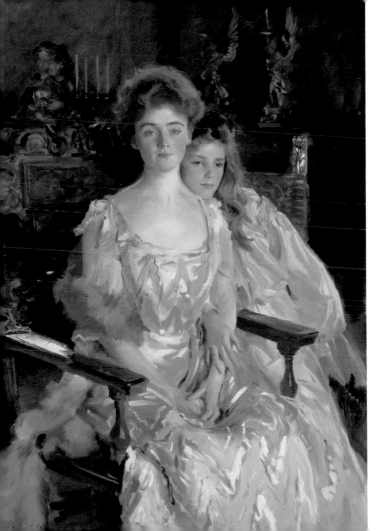

*All that I am, or hope to be,
I owe to my angel mother.*

Abraham Lincoln

Gustav Klimt, *The Three Ages of Woman*, detail,
1905, Galleria d'Arte Moderna, Rome.

392

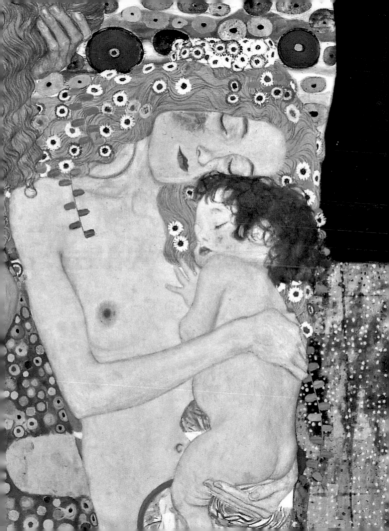

A woman has two smiles that an angel might envy, the smile that accepts the lover afore words are uttered, and the smile that lights on the first-born baby, and assures him of a mother's love.

Thomas Chandler Haliburton

Luigi Rossi, *The Flower Bed*,
1905–1910, private collection.

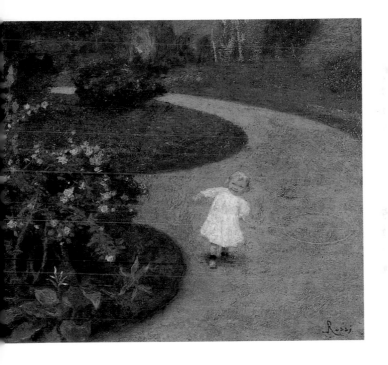

I sketched a young mother with her child at her breast, sitting in a smoky hut. If only I could someday paint what I felt then! A sweet woman, an image of charity. She was nursing her big, year-old bambino, when with defiant eyes her four-year-old daughter snatched for her breast until she was given it. And the woman gave her life and her youth and her power to the child in utter simplicity, unaware that she was a heroine.

Paula Modersohn-Becker

Paula Modersohn-Becker, *Reclining Mother and Child*, 1906, Paula Modersohn-Becker Museum, Bremen.

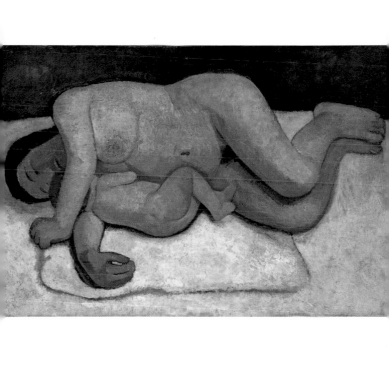

Parents who expect gratitude from their children (there are even some who insist on it) are like usurers who gladly risk their capital if only they receive interest.

Franz Kafka

Gari Melchers, *The Grove*, 1908, Musée National de la Coopération Franco-Américaine, Blérancourt, France.

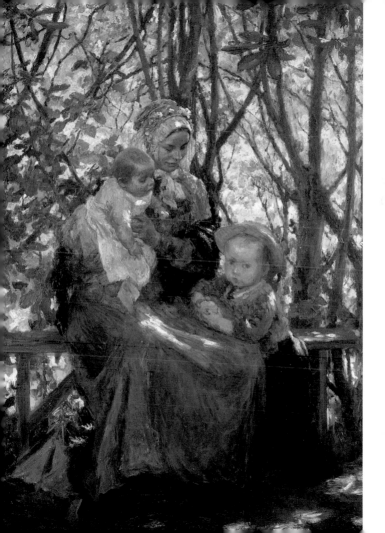

O, I got a zoo, I got a menagerie, inside
my ribs, under my bony head, under my
red-valve heart—and I got something else:
it is a man-child heart, a woman-child
heart: it is a father and mother and lover.

Carl Sandburg

August Macke, *Large Zoological Garden*, detail, 1912,
Das Museum am Ostwall, Dortmund, Germany.

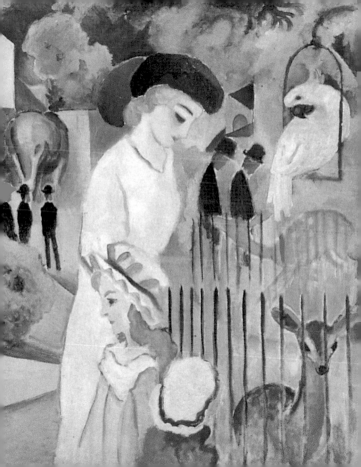

Here, under my heart
you'll keep
till it's time
for us to meet,
& we come apart
that we may come
together,
& you are born
remembering
the wavesound
of my blood,
the thunder of my heart,
& like your mother
always dreaming
of the sea.

Erica Jong

Marc Chagall, *Maternity (Pregnant Woman)*, 1913,
Stedelijk Museum, Amsterdam.

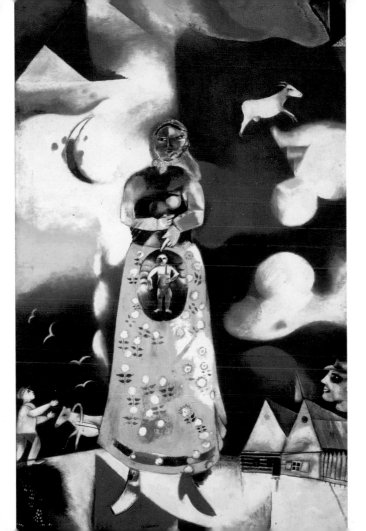

My mother and I could always look out the same window without ever seeing the same thing.

Gloria Swanson

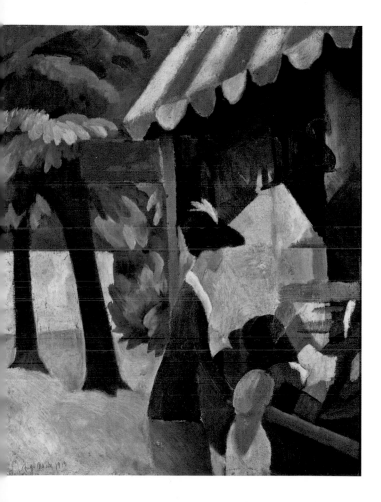

Surely I have behaved and quieted myself, as a child that is weaned of his mother: my soul is even as a weaned child.

Psalms 131:2

Gino Severini, *Motherhood*, 1916,
Museo dell'Accademia Etrusca,
Cortona (near Arezzo), Italy.

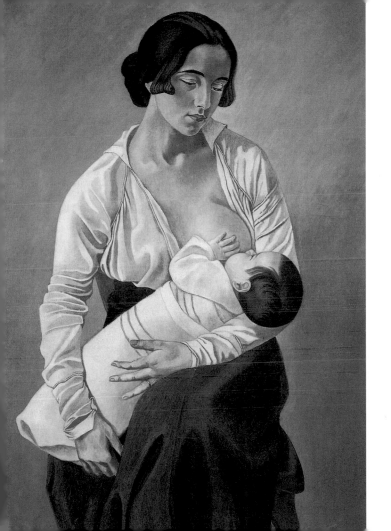

I went softly into the room. She was sitting by the fire, suckling an infant, whose tiny hand she held against her neck. Her eyes were looking down upon its face, and she sat singing to it.

Charles Dickens

Marc Chagall, *Bella and Ida by the Window,* 1916, private collection.

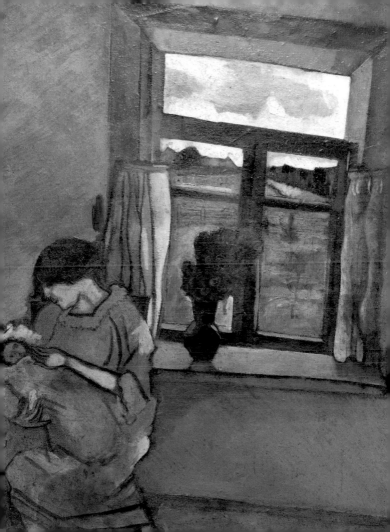

*T*he mother-child relationship is paradoxical and, in a sense, tragic. It requires the most intense love on the mother's side, yet this very love must help the child grow away from the mother, and to become fully independent.

Erich Fromm

Egon Schiele, *Nursing Mother*, 1917, private collection.

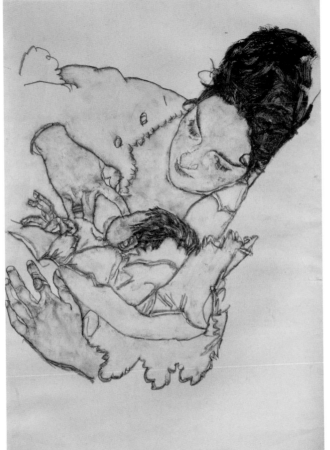

A mother's love determines how we love ourselves and others.

Nicholas Gordon

Pablo Picasso, *Maternity*, 1921, private collection.

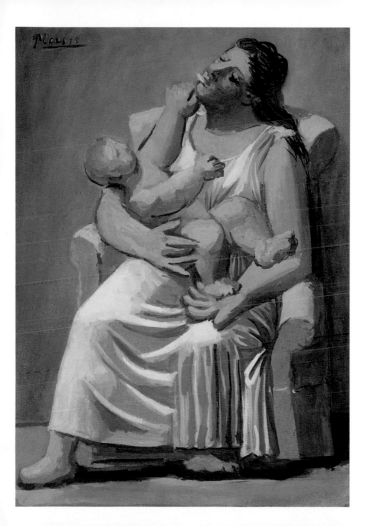

Hearing her husband's footstep, she turned towards him, summoning him to her with her smile. With one hand she was supporting the fat baby that lay floating and sprawling on its back, while with the other she squeezed the sponge over him.

Leo Tolstoy

Joaquín Sorolla y Bastida, *Mother and Child after a Bath*, 1923, Museo Sorolla, Madrid.

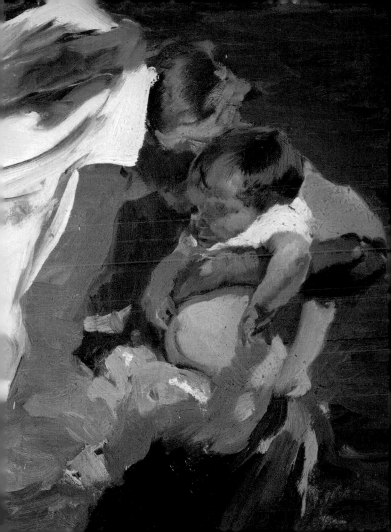

Like a newborn puppy,
You bit the back of my neck
And smile at me,
And then you cry,
Reminding me that it's my duty
To stay close to you.

Alda Merini

David Alfaro Siqueiros, *Madre campesina*
(*Peasant Mother*), 1929, Museum of Modern
Art, Mexico City.

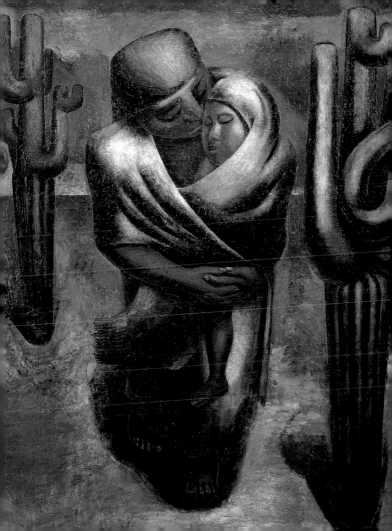

When you were born
A garden was born,
The flowers were of all kinds;
The scent carried a long way
Especially the jasmine.
If you knew how much I love you
You'd light a little campfire
In the middle of the sea,
You'd make garlands of flowers,
And you could never stand to be
Without your mother.

Italian nursery rhyme

Dorothea Sharp, *Little Boy Picking Daisies*, 1925,
private collection.

Most American children suffer from too much mother and not enough father.

Gloria Steinem

Caffaro Rodè, *Advertisement for the Fiat Ardita*, 1933, Fiat Archives, Turin, Italy.

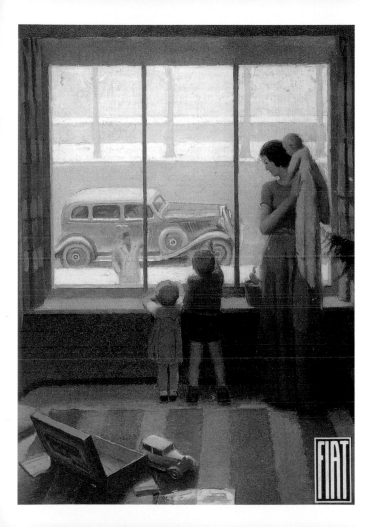

*A city suspended in air
my last banishment,
and gentle women of long
ago calling around me;
my mother, made new by the years,
sweet hand choosing the whitest
roses to bind my head.*

Salvatore Quasimodo

If you bungle raising your children, I don't think whatever else you do well matters very much.

Jacqueline Kennedy Onassis

Gordon Odell, *Keep These Hands Off!* 1942, fund-raising poster for Victory Bonds.

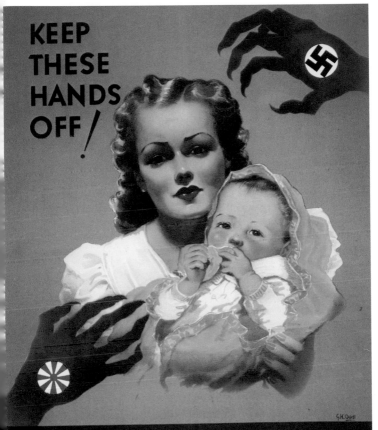

A Freudian slip is when you say one thing but mean your mother.

Author unknown

Charles Spencelayh, *Mother,* Bradford Museums
and Art Galleries, Bradford, UK.

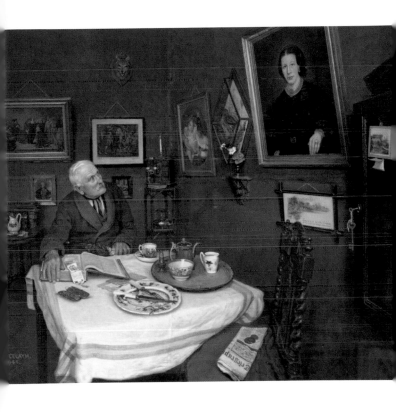

When I was a child, my mother said to me, "If you become a soldier, you'll be a general. If you become a monk, you'll end up as the pope." Instead I became a painter and wound up as Picasso.

Pablo Picasso

Pablo Picasso, *Maternity with Green Apple*, 30 August 1971, private collection.

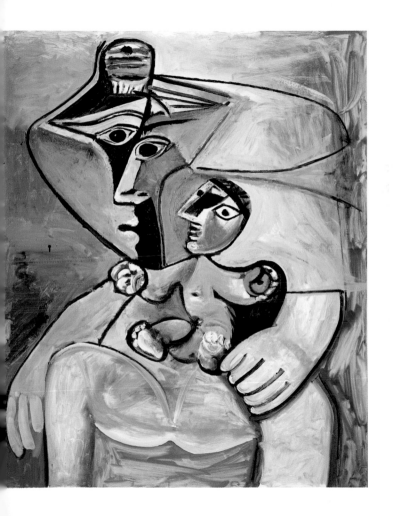

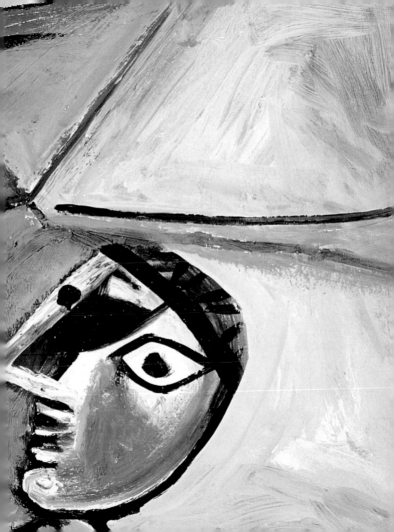

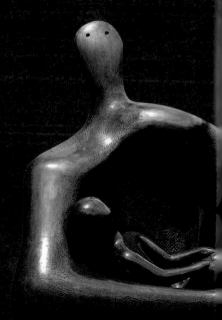

*I see the sleeping babe, nestling
the breast of its mother;
The sleeping mother and babe—
hush'd, I study them long and
long.*

Walt Whitman

Henry Moore, *Draped
Reclining Mother and
Baby*, 1983, private
collection.

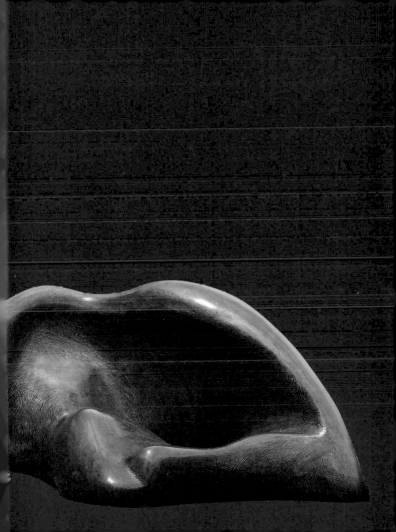

When my mother had to get dinner for 8 she'd just make enough for 16 and only serve half.

Gracie Allen

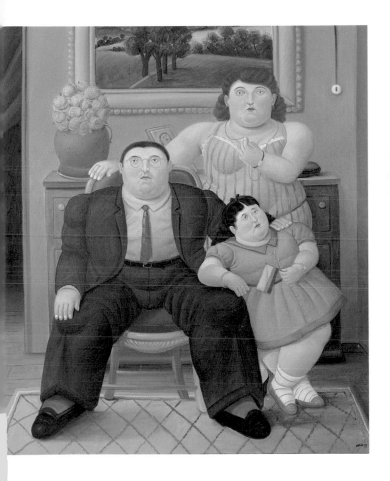

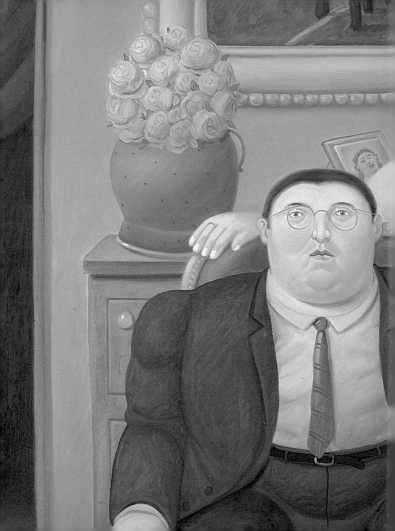

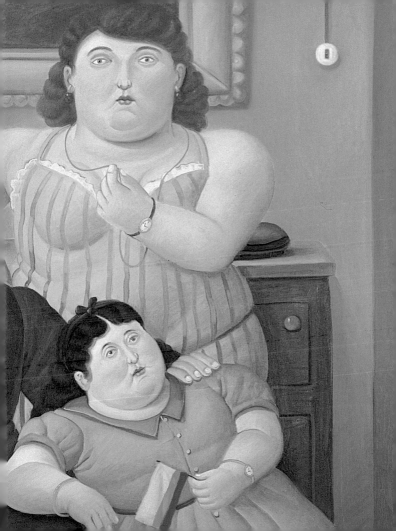

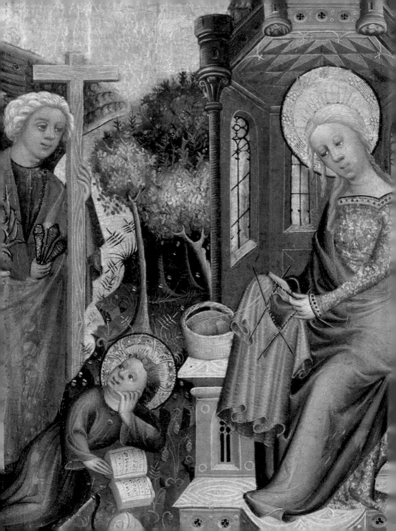

Appendixes

Index of Artists

Index of Authors

Text Credits

Photographic Credits

For Mondadori Electa:
Series Editor: Stefano Zuffi
Original Editorial Coordinator: Virginia Ponciroli
Original Graphic Design: Dario Tagliobue
Original Layout: Elena Brandolini
Original Image Research: Simona Bartolena & Matteo Penati
Original Technical Coordinator: Lara Panigas
Original Quality Control: Giancarlo Berti

For Getty Publications:
Gregory M. Britton, *Publisher*
Ann Lucke, *Managing Editor*
Pamela Heath, *Production Coordinator*
Hespenheide Design, *Typesetter*
Anthony Shugaar, *Translator and Research Coordinator*